LOST TOWNS
OF
NEW ENGLAND

LOST TOWNS
OF
NEW ENGLAND

RENEE MALLETT

THE
History
PRESS

Published by The History Press
Charleston, SC
www.historypress.com

First published 2021

Manufactured in the United States

ISBN 9781467147866

Library of Congress Control Number: 2021941610

*This book is for Lyn, who was a good sport
about having to go outside and spend time with her mother.*

Contents

Contents

INTRODUCTION

For the past I don't know how many years, I have traveled by boat to tiny Star Island, ten or so miles off the coast of New Hampshire, to work on whatever book it is that I'm currently writing. But while working on this book in 2020—the year of the plague—Star Island was closed to visitors. On a clear day, I could stand on the shore in Rye, New Hampshire, and see it, just barely, as a dark smudge neatly dissecting the sea and the sky, swirls of blue and white above and below it. But I could not walk its rock-strewn paths myself or idle an afternoon away rocking on the porch of the Oceanic Hotel, and I felt the loss keenly.

While I missed my annual retreat to the Isles of Shoals immensely, there is also something uniquely apropos about writing a book on ghost towns in the middle of a pandemic. Disease, of course, is one of many reasons why people throughout history have pulled up their lives and abandoned their villages. During the earliest days of quarantine, as more and more things closed one by one, including the schools my children attended, I trekked out into the wilds of New England to conduct research for this book. My oldest daughter, a teenager, came with me on these trips more often than not. Sometimes, we ended up taking wild side trips, going to closed amusement parks and crumbling cottages just for the sake of coming back with a good story to share with our friends via Zoom that night.

In those first few weeks of the pandemic, when it seemed like we knew nothing and nowhere was safe, Lyn and I were having if not the time of our lives, at least a period of time I know I'll look back at with a

strange sort of fondness. My oldest daughter is an old soul. She reads good books, has an amazing group of friends who will someday take over the world and make it better for all of us, and is navigating those awful, confusing early teen years with grace and fire—well, mostly. I'm lucky that (knock on wood) we've made it this far into her teenaged years and are still friends.

The two of us would drive for hours up and down dirt roads, stopping at interesting cemeteries, looking at the shadows created by trees, trying to find the unmarked path that would lead to whatever collection of cottages and stone walls we were looking for that day. Some days, we couldn't find any of the places on our list, but I never felt the trip was wasted. The rest of the world was hunkered down at home, watching the news compulsively, while we cruised unnamed back roads, singing along loudly with the radio and talking about our favorite books. Other times, we'd find our destination, and we'd walk in a comfortable silence, just enjoying being surrounded by the forest and finding a little oasis of peace in what I hope will be the strangest time of both our lives.

People say she is the child of mine that is most like me, but this is not true. I have five children, and every single one is exactly like me—just in totally different ways. I think of it like a prism. My personality has been split into five distinct different paths of light, and each child is one of the separate colors. Lyn is, however, I will agree, the child that is most obviously like me. We both have the same kind of manic extroverted/introverted dueling personalities. Some days, we'd chatter endlessly at each other as we hopped over fallen stone walls or pulled each other up over even larger boulders. Other times, we'd walk in a companiable, easy silence, happy to enjoy the great outdoors and feeling no pressure to fill the silence with needless small talk. We'd think our own thoughts, take a casual pace, only calling out the necessary "cellar hole" warning every so often as was needed.

I don't want to give too much of an idyllic portrait of these trips. They weren't all "mother/daughter bonding in the wilderness" experiences. This was early spring in New England. The weather could turn in an instant. We'd spend one day with our teeth chattering from the chill and rain, and the next day, we'd come back stripping off sweat-soaked clothes. On one memorable occasion, I completely misjudged the depth of a gully and ended up soaked to the waist in fetid swamp water while my daughter shrieked happily, "There's something dead in there, right next to you!" It was a smelly ride home.

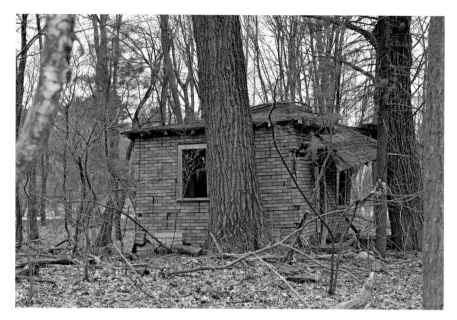

One of the Star Cabins located along the edge of Route 1, near Peabody, Massachusetts. These little bungalows were popular places for travelers to stay in the 1950s. *Photograph by Renee Mallett.*

The interior of a Star Cabin (my teenaged daughter refused to pose in the ruins). *Photograph by Renee Mallett.*

I have now spent most of my adult life writing about haunted houses and abandoned places. I've spent the night in rooms where famous murders have happened, walked the hallways of old asylums and spent more time in buildings with huge gaps in the floors and caved in ceilings than I care to think about. My tolerance for risk is higher than that of the average middle-aged mom. But there's a special kind of fear that comes with walking for an hour through the woods before stumbling on an off-the-grid trailer, apparently occupied, when you have your fourteen-year-old daughter by your side. Other times, I drove her crazy, asking her to slide in through a hole in a foundation or to climb up onto a rotten front porch for a photograph opportunity. She turned me down every time with the stern warning that her friend's mothers did not ask their daughters to do these kinds of things.

But even the misadventures gave us both interesting stories to tell. In fact, when we started making these trips, I assumed she was just looking for Instagram content or a way out of the house during a pandemic. But slowly I noticed that every day, we'd go to a new place, and she'd ask, "So what's up with this place? What happened here?" Because the history behind an abandoned village is the ultimate interesting story, isn't it? It's strange enough when you consider the neglected house or two in your own town— what could happen to cause an owner to dump a home? But then when you consider an entire town, what series of unfortunate events had to occur to make every last resident pack it up and leave—and for no one to want to come and replace them?

Usually, when we think of ghost towns, we think of scatterings of buildings turning pale and gray under the desert sun in Old West villages that rose and fell in a short amount of time. But New England is not the Southwest. Space is at more of a premium here. Things left are quickly developed into something new. Our old wood buildings rot. But if you know where to look, there are still discarded remnants of the past to be found and explored.

LOST

Abandon [uh-ban-duhn]
verb (used with object):

To leave completely and finally; forsake utterly; desert:
to abandon one's farm;
to abandon a child;
to abandon a sinking ship.

To give up; withdraw from; discontinue:
to abandon a research project;
to abandon hopes for a stage career.
to give up the control of:
to abandon a city to an enemy army.

—From www.Dictionary.com

HARD TIMES IN THE MILLS

Industrialization began in earnest in England but came relatively early to the New England states. The same plentiful lakes and rivers that tourists love today were originally the early powerhouses of the mills that sprang up with increasing frequency in the late 1700s and early 1800s. Samuel Slater, a British engineer, got a group of Rhode Island businessmen to fund the first mill in the United States in the 1790s. By 1812, nearly one hundred mills had popped up around this part of the country. With lots of running water and, later, steam to power machinery, the mills quickly grew into important centers of New England life.

The earliest of New England's mills were fairly small compared to what they would grow into later. Most employed fewer than seventy people and relied on family units as blocks of employees. These family units acted as early transitions from the family farms to the mills. The father would be the "manager," who oversaw the work done by his wife and children. But this system quickly fell by the wayside as the mills grew larger and employed more and more people in a relatively short amount of time.

Many everyday items that were originally made by hand on individual family farms or made for a price by a skilled craftsman could suddenly be made relatively quickly and very cheaply in the mills. This was both a blessing and a curse. Skilled craftsmen were suddenly squeezed out of the market. But items that were once only available to the wealthy were suddenly in reach of more and more people. And people who were not landowners themselves had more job opportunities than they had

Slater Mill in Pawtucket, Rhode Island, was the first successful cotton mill and paved the way for further industrialization in New England. *Courtesy of the Library of Congress.*

previously. As much uncertainty as industrialization brought, it was still a welcome change for many.

Young women were among the first benefactors of the switch from an agricultural system to an industrial one. Instead of living their lives on the farm—first their fathers' and then their husbands'—many moved to bigger cities and got jobs independent from their family for the very first time. But of course, they did not have real freedom as truly independent ladies. Knowing that their families would worry about the mill girls becoming too urbane and modern, many of the factories set strict protocols for the unmarried women who sat at their looms. Swearing was often forbidden, church attendance was mandatory if they were not scheduled to work and most of the girls lived in company-owned boardinghouses that were strictly female-only, with curfews and no male visitors allowed.

That's not to say there weren't any benefits for the traditional New England farmers as well. The dawn of the mill era coincided with the rise of the huge midwestern farms. The small family farm of the Northeast

couldn't compete with the massive amounts of fresh food that the very large and very fertile land in the middle of the country could produce. People who had been part of farming communities for generations then had the option of mill work or switching their farming practices to support the demands of the mills. While everything from clock parts to paper were made in New England's mills, much of the work centered around the textile industry. Local farms could switch to raising sheep and find buyers for the wool roving as close as the next closest city with a mill.

The mills didn't just change life on the farms, they changed city life as well. Seemingly overnight, a small village could become an important urban center with the addition of a mill. By and large, these were all company towns. The residents worked in the company mill, bought everything they needed at company stores and brought those goods home to the houses they rented from the same company. Oftentimes, millworkers were not paid in actual cash. The company that owned the mill would instead pay them in credit that could be given back to the same company as rent for their homes or goods from their stores.

This same convenience was, for some places, also their downfall. When an entire town was owned—from the roads to the jobs—by one company, the

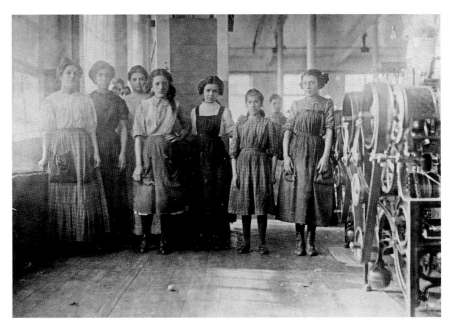

Mill girls at work in Fall River, Massachusetts, in 1912. *Courtesy of the Library of Congress.*

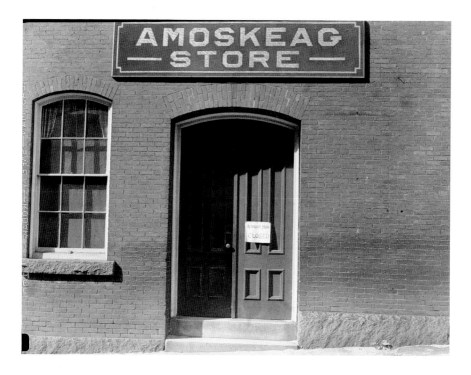

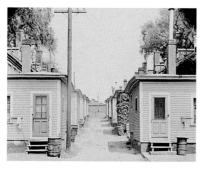

Above: The Amoskeag Company Store in 1936 in Manchester, New Hampshire, was owned by the same company that owned the mills and rented housing to the mill workers. *Photograph by Carl Mydans, courtesy of the Library of Congress.*

Left: Company-owned housing in 1937. Small homes, such as these built and owned by Manchester, New Hampshire's Amoskeag company, were rented to their workers. *Photograph by Edwin Locke, courtesy of the Library of Congress.*

future of everyone rested on the company's shoulders. If the mill failed or the company that owned it went under, it could spell disaster for everyone. With so much of New England life centering around the mills, it should come as no surprise that they caused nearly as many ghost towns as they caused towns to thrive. Across the Northeast, you can find the remains of many towns that were done under when the mills went belly-up.

DANIELS VILLAGE, CONNECTICUT

Gristmills, though still in use today in a more mechanical form, are probably more or less unknown to the average modern-day reader. Even though the image of a gristmill with a large wooden waterwheel is a familiar one, few seem to know their purpose. They are one of those things that were of vital importance to our ancestors that we give almost no thought to today. Even if most people can't name what the building does, we all seem to share a collective memory of the iconic waterwheel spinning away on a historic building.

What those wheels, powered by the flow of water, were busy turning were two colossal millstones inside the building. The enormous weight of the stones turning would slowly grind grains and corn into cornmeal or flour. It was a tedious process that took a great deal of time and effort to do by hand and one that could be done relatively easily with a gristmill. This made the mills important centers of industry and community for our ancestors. Fortunes rose and fell with the success of a gristmill, not just for the mill owners, but for everyone in the surrounding community who relied on it.

In this case, the entire inception of a town can be credited to the construction of a gristmill. The land along the Five Mile River was originally owned by John Fiske, who was a reverend in the nearby town of Killingly, Connecticut. Over the years, Fiske slowly sold off some small parcels of land. Each land sale resulted in a new family moving in and building up farms. But the population boom came about when one of these new transplants, Jared Talbot, who had a small stretch of land along the Five Mile River, built the first gristmill in the area around 1720.

With the hard and tiresome labor of grinding corn able to be done by the mill, people began moving into the area in a steady stream. In 1760, Jared Talbot would take on a business partner and add a sawmill, tanning operations and a boardinghouse near the Talbot Mill. In time, the area around Talbot Mill came to be known as the village of Talbot's Mills. The town had its own school, a cider press and easy access to the surrounding area, thanks to an extension of the Stone Road, which first began to make its way through the area in the early 1700s and can still be seen today.

In 1814, the town had become enough of an industrial center that several businessmen from Rhode Island went in together and built a large cotton mill to go with the other factories that were already chugging along at Talbot's Mills. The Rhode Island entrepreneurs named their new business Howe's Factory and poured great sums of money into the venture. They moved the original gristmill that was built back in 1720 away from its original location

so they could dam the river and add in a new hydraulic system to power their cotton mill. A large blacksmithing operation was added to support whatever tools or repairs the cotton mill needed. They also put in a long line of tenement houses to rent to the workers they would employ at the mill. In order to carry out such a massive undertaking in an already well-established township, the men from Rhode Island convinced many of the existing local landowners to sell their parcels to them for a premium price.

This first consolidation of the town made it very easy for the Daniels family to come in thirty years later and buy nearly all of Talbot's Mills in one fell swoop. They owned the gristmill, the cotton mill, the blacksmith shop and pretty much everything else. Changing the name of the town from Talbot's Mills to Daniels Village seemed the next logical step.

The Daniels family owned the town for less than half the time that the Rhode Island developers had. In a sudden stroke of bad luck, the cotton mill burned in 1861. While the family debated over whether to rebuild or try their hand at something new, the residents of Daniels Village wandered away, one or two families at a time, looking for work in the many of the other mills that had popped up throughout New England in recent years. The family put the town up for sale, from the stone dam to their own spacious family home, and waited for a buyer who would be interested in buying the whole thing at once—the same way they had sixteen years prior. The Daniels would have to wait until 1880 for a buyer to come along that would be interested in buying a town that had no residents and no industry.

Even as early as 1915, accounts say that Daniels Village had been reduced to something less than a ghost town. The stone mansion where the mill manager had lived was still standing, along with the stone dam that was built to power the cotton mill that no longer existed. Nearly everything else had been reduced to nothing more than cellar holes.

It is not all that different from what can still be seen when visiting Daniels Village today. The stone house, now a private residence, still sits boldly at the corner of Stone and Putnam Roads. The local preservation commission holds an annual history walk that makes stops along the Stone Road to view the cellar holes. The rest of the year, this privately held land is an active and ongoing archaeological dig—same as it has been since the early 1980s. Daniels Village was added to the National Register of Historic Places in 1978.

LIVERMORE, NEW HAMPSHIRE

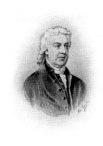

A lithograph of Statesman Samuel Livermore. His granddaughter would name a town after him. *Courtesy of the Library of Congress.*

While anyone looking into the past of Livermore, New Hampshire, will find an abundance of playful, if somewhat awkward puns, trying to rhyme "Livermore" with "never more" or "forever more," a more serious recorded history of this once-thriving town is harder to find. Located about sixteen miles west of North Conway, just a few miles from Bartlett, the former village is now part of the White Mountain National Forest.

One thing that is not a mystery is the origin of the town's unusual name. In 1874, a lumber operation named the Grafton County Lumber Company was started in New Hampshire's north country by two brothers, both Boston lawyers, named Daniel and Charles Saunders. Livermore is the town that sprang up to support the workers of that lumber company. The brothers named the town after Samuel Livermore, a New Hampshire state senator who was also the beloved grandfather of Daniel Saunders's wife.

If anything can be said of the Saunders family, it's that they had impeccable timing. They were able to buy a vast amount of north country land very cheaply in 1874 due to the relative remoteness of the property. But in 1875, the Sawyer River Railroad was created. Although it was only eight miles long and created almost solely to haul lumber, and the occasional passenger, the railroad served to immediately tie the village to the surrounding area. The Grafton County Lumber Company, helped along by the railroad, did so well that within just one year, a town had sprung up to support the workers. When the first sawmill burned in 1876, residents built two additional mills to replace it within a year's time.

In 1885, the town had 153 residents, 28 of whom were children, plus an always changing number of lumberjacks and the like who would come to work for just a season and then move on to the next project somewhere else. The one school in town was valued at $151, from the building down to the books. The two schoolteachers were paid $26 a month to teach all 28 children together in one room.

Livermore was, from start to finish, a true company town. The Saunders family built and rented out the homes in town. The Saunderses themselves only lived in town part time, but they made sure they had stately

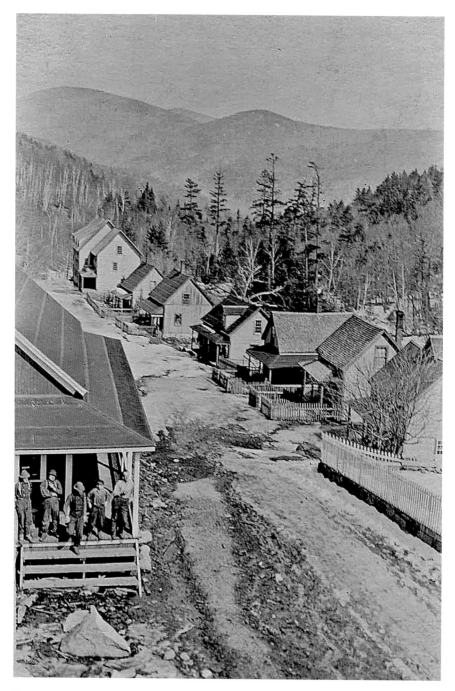

The main street of Livermore. In the far back is a glimpse of the Saunders mansion.
Courtesy of the Boston Public Library.

accommodations for when they were there. Their own home, a sprawling Victorian manse, with twenty-six rooms, three chimneys, two wide wrap-around porches and more peaked roofs than a modern-day McMansion, was the largest building in town outside of the sawmills. The Saunders family owned absolutely everything if you traced it back far enough. The largest store in town, where you could buy anything and everything from a dress to wear to church to the family groceries for the week was the Livermore Company Store. But even the smaller specialty shops in Livermore were all company stores, owned by the logging company, and buying outside of town was quite definitely frowned on. One enterprising store owner in the neighboring town of Bartlett would bring a wagon packed with groceries in the dead of night to the top of Livermore Road. Thrifty town residents could buy produce from the back of his wagon under the cover of darkness.

Bargain hunters weren't the only Livermore denizens to be found sneaking down the road out of town in the dead of night. Logging was hard and dangerous work. Oftentimes, the men in the camps were not experienced lumberjacks. Farmers who were looking to make money through the winter months, young men who were looking to leave the family farm or recent immigrants who had a hard time finding work elsewhere would sign on for a season and then decide the sparse and filthy life in the camp was not for them. Defection became enough of an issue in Livermore that the Saunderses hired a man named Sydney White to track down those who left before their contract was up. One night, White confronted one of these runaways and ended up shooting him in the leg. A closely watched court case followed that resulted in a $3,000 fine for the Grafton County Lumber Company.

Unlike most of the timber operations of the time, which clear-cut forests as quickly as possible, the Saunderses believed in sustainable logging. Only select trees of a certain age, kind and size were allowed to be harvested. This ensured that, over the course of many years, there would always be more trees to cut. The system also allowed for the natural checks and balances of the forest ecosystem to remain in place. While most of the woods owned by New Hampshire's lumber barons would fall victim to massive forest fires over the years, the land around Livermore never had the same problem. While the forward-thinking policies of the Saunders brothers should have kept the town of Livermore a profitable place to live for many generations, there were some things that they could not control.

While the forests around Livermore never burned, the sawmill did. In 1909, an accident in the mill caused a large portion of the structure and a large stockpile of lumber to be damaged. That same year, a fire damaged part

of the Saunders mansion. In 1917, Daniel Saunders passed away. Charles finished rebuilding the sawmill, but in 1920, human error would cause it to burn for a second time. This time, it was a total loss of the building. It would be two years before the rebuilding of the sawmill would be completed, but during that time, Charles passed away as well.

The company was already on shaky footing before the death of Charles Saunders. Several years of low to no output from the damaged sawmill, plus the high cost of repairing and rebuilding it, meant there was not much of a financial cushion when Charles died. The company and the town of Livermore were left to three younger Saunders sisters, who had no experience in the timber industry or in running a business at all.

Even still, Livermore might still be a town today had an early nor'easter not come through the area in November 1927. Although the town of Livermore was perched high above sea level, the much higher elevations of the mountains surrounding it, like Mount Osceola and Mount Carrigan, meant it actually counted as low ground. Rainwater poured down from the mountains, flooding Livermore and washing away all but one of the town's sawmills. The one sawmill that remained was in terrible disrepair after the storm and could no longer be used. On top of this, the storm destroyed much of the timber in the surrounding forests.

The result of the storm was devastating for Livermore. First, the lumberjacks left, moving along to where there were trees ready to be cut down and where there were sawmills to process them. Without this transient population, the shops in Livermore began to fail. When no new industry moved in to take over the place logging had held for so long in the area, there was little that the year-round residents could do to hang on to their homes.

Some longtime residents of the town would say that the real demise of Livermore had nothing to do with the storm or the hit the logging industry took because of it. Those people would say that the June 28, 1928 death of Big Jim Donahue marked the real end of Livermore. Donahue had come to the area before the town was even properly a town. He started off as a foreman at the first sawmill, worked his way up over time to mill manager and then, once the town proper was formed, he fulfilled every post possible, from town manager to selectmen and railroad agent to postmaster.

Whether felled by the big flood or if the heart just went out of everyone with the death of Big Jim, by 1937, Livermore had become enough of a ghost town that the United States Forestry Service was able to buy all of it, with the exception of twelve meager acres, for nine dollars an acre to add to the White Mountain National Forest. In 1949, the last two residents left

in the twelve-acre town, caretakers Joe Platt and Bill MacDonald, finally gave up the ghost, packed up their things and left. Livermore was officially disincorporated in 1951. In 1965, the remains of the Saunders mansion were burned; the mansion had proven an attractive target to vandals and salvagers, and the structure was unsafe.

The twelve acres the Saunders sisters had held back from the land agreement with the state continues to be in private hands. Where the Saunders mansion once stood, there is a cabin. A clerical error in 2000 would accidently mark the cabin as the home of two people, making it seem, at least for a moment, as if Livermore had two residents left.

A surprising amount of Livermore can still be seen today. Hikers traveling through the White Mountain National Forest are sometimes surprised to stumble on the remains of the town. Many cellar holes can still be seen. One, once the site of a prosperous store, still has a safe built into the old foundation. Where the railroad once ran through town, bringing lumber to be sold in larger cities, can also still be seen in some places. The Sawyer River Trail, near Bartlett, New Hampshire, follows one of the old Livermore roads and is an interesting hike for anyone curious about the abandoned village.

DAVIS MINING TOWN, MASSACHUSETTS

The fact that a large outcrop of pyrite existed in the wooded hills between the Massachusetts towns of Rowe and Charlemont was known at least as early as 1840. But it wasn't until 1882, when H.J. Davis secured rights to mine the pyrite, that the real significance of what was under the ground became known. Along with iron pyrite, better known as fool's gold, there was also a good quantity of sulfur and copper. In short order, the H.J. Davis Company had sunk four mines in a small area and were producing a reported one hundred tons of pyrite a day, making it the largest mining operation in Massachusetts at the time.

Shortly after the mining began, other businesses sprang up around it. First, a blacksmith shop was created to make and repair tools for the mine. Then a butcher shop followed. Once the mine workers could get food and tools, the only thing they needed to make it a real town was some place to live. In short order, 150 homes were built. But this was not some hardscrabble little ramshackle mining village. Iron pyrite could be used to

make sulfuric acid, which had important commercial uses. As the money poured in, H.J. Davis spread the wealth, paying his mining workers twelve to fifteen dollars a day—a considerable wage in the late 1800s.

The wealth spread from the Davis Mining Town, even to the nearby towns of Charlemont and Rowe. The profitability of the Davis Mine was so well known that a miniature prospecting craze swept the entire area. The Massachusetts Talc Company and the Foliated Talc Company soon gained traction, becoming profitable businesses in their own right, but an untold number of prospectors with increasingly smaller claims soon filled the hills surrounding the three towns, as everyone was trying to cash in and get rich quick.

Before the creation of the Davis Mine, Charlemont had a couple of very small sawmills and a chair-making shop. With the wealthy miners from Davis looking to spend their earnings and people flocking from nearby to try prospecting themselves, industry and shops began to thrive in the nearby village. Charlemont claims to have been the first town in Massachusetts to have electricity—a direct result of the economy generated by the Davis Mine.

The mine even attracted tourists. In the early 1900s, H.J. Davis constructed an observation tower above the main pyrite shaft and charged the curious a few cents to climb to the top. The tower offered a bird's-eye view of the mine, the blacksmithing operation and the rest of the village spread out behind it.

In 1911, it all came crashing down, quite literally. Fifteen levels of the Davis Pyrite Mine collapsed. By sheer luck, no one was killed in the catastrophic cave-in. It was soon revealed that the mine had operated for nearly thirty years using poor mining practices that increased profit but more or less guaranteed that a disaster was going to happen.

The H.J Davis Company never recovered, and the town went down with it. With most of the residents out of jobs permanently, families packed up and left for better opportunities. By 1937, the town was fully abandoned, and most of the homes were reduced to cellar holes.

The town and the mine remain in ruins today on private property. The University of Massachusetts–Amherst has received a $1.59 million grant to study the site. When the mine collapsed, a rush of groundwater began to fill the remaining tunnels before it made its way downhill to the Davis Mine Creek. At times, the iron sulfide contamination is so strong, the creek is said to be more acidic than vinegar.

Hanton City, Rhode Island

Hanton City, Rhode Island, is unique in many ways. It's one of the most well-known abandoned towns in Rhode Island (as far as name recognition), but there is not very much that is actually known about its history. It has a reputation for being Rhode Island's "Ghost City," but there are not really any paranormal myths associated with it. It is unique in comparison to many of the other towns in this book because instead of Hanton City's mill failing and taking the town down with it, as best as anyone can tell, it was the rise of the mills that was its undoing.

Local historian Jim Ignasher believes that Hanton City was settled in the late 1670s, after the end of King Phillip's War, by members of three loyal British families: the Paines, the Hantons and the Shippees. He believes the land grant may have been a payment for services rendered during the war. Others have speculated that a family named Harrington were the original settlers; in the colonial era, the pronunciation of Harrington was "Hanton," and thus Hanton City was born. There are more surviving fictitious stories about Hanton City than truths. Popular legends say it was a city of freed enslaved people or that it was the local poor farm, where debtors, the mentally ill or the physically disabled would live out their lives in quiet dignity with some charity from their neighbors. The historical record—what is left of it—does not back these stories up.

Regardless of whether the Hantons or the Harringtons were among the first settlers, if it was a payment for work done, it must not have been for work that was done well. While Hanton City is in a pleasant enough spot, it is in the absolute middle of nowhere, even by colonial standards. There is rich soil but dense woods and a lot of very large slabs of stone dotting the landscape. But the settlers were as practical as they were imaginative. Homes were built using as much of the natural stones, exactly as they were already poking up out of the ground, as they could. A combined schoolhouse and meeting house was built between two large ledges. Just by adding a roof along the top of the ledges and walls capping either end, the stones served as two out of four of the building's outer walls. With no steady river running by to power a gristmill, the residents of Hanton City instead ground their corn and threshed their grain using one of the low flat boulders that dotted the landscape. The townsfolk of Hanton City were skilled at turning what should have been disadvantages into assets.

Being so far off the beaten path also ended up working in the town's favor. What is now the city of Woonsocket was a popular place, even during the

eighteenth century. The indigenous Native tribes had long relied on the area for its abundance of game. It was no different for the English settlers. But it was a long trip to get there from absolutely anywhere else. The people of Hanton City, knowing they were among the closest village—even if they weren't really very close at all—made it their habit to leave a loaf of bread and a little bit of home-brewed beer in a small building near the road. Any traveler passing by was welcome to stop and rest. Most travelers left a coin or two when they could in appreciation. In time, it became well known to anyone passing through the area that the people of Hanton City were friendly and accommodating to strangers. Travelers began to make it a point to plan their trips so they could take a break when they reached Hanton City.

The town couldn't solely rely on being a rest stop for tourists. The townspeople did some quarrying of the area's many rocks, but most of the townsfolk made their living as tanners and, later, shoemakers. Shoemaking was a skilled artisan craft that was much sought after during the time. Every shoe was made, painstakingly, by hand from the tanning and cutting of the leather to the stitching and sizing. It was a premium product that even during a time when most people did as much as they could for themselves, most anyone who could afford to would rather pay for a pair of shoes than make some on their own.

Shoes, however, were among the first things to be made by factories when industrialization came to New England. An assembly line–style production and as much mechanization of the process as possible suddenly meant that shoes could be made quickly and cheaply, especially when compared to the handcrafted process that had been used up to this point. At the same time, new roads were being built to reach the factories that were making the shoes, and these new roadways all passed the out-of-the-way little hamlet of Hanton City. As people got poorer and life got harder, families drifted away, one by one. There was work to be had in the mills after all, and there was no reason to hang around Hanton City when there were no jobs to be found there. It was a death of many tiny little cuts, not a single monstrous blow, but the end result was the same. Hanton City ended up deserted, its history mostly obscured.

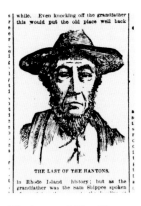

THE LAST OF THE HANTONS.

The image of Tom Hanton that ran with the article about him and his sister being the last residents of Hanton City. *Courtesy of the Library of Congress.*

It's not entirely clear when Hanton City finally gave up the ghost. A *Providence Journal* article from the 1880s describes the town as though it was long since abandoned even at that time. But nine years later, the same paper interviewed eighty-year-old Tom Hanton and his sister who claimed to be the last two residents, living in a one-room shack at the very edge of the town. Much of what is known about Hanton City comes from the recollections the siblings shared with the newspaper at that time.

Aside from the slabs of natural stone and cellar stairs made from the same stone, you can still find a small cemetery and what are possibly the remains of a corncrib—if you know where to look. Hanton City is still pretty out of the way, and the forest has been allowed to grow in around it so much that if you don't know what you're looking for, it's easy to miss.

2

UNDER THE SEA

When you've spent most of your life writing about the history, legends and lore of New England, people tend to assume that you are a born-and-bred Yankee. Although I have spent more than half of my life in Massachusetts and New Hampshire and have always felt that I'm a true New Englander at heart, my childhood was passed in Upstate New York, not New England. Like most of the kids raised in New York's Capitol District, I spent most of my summers sunburned, sandy and wearing the same damp bathing suit for more days at a time than I care to think about now, swimming in the Great Sacandaga Lake.

Upstate New York has many big, popular lakes. The Finger Lakes can be found a few hours' drive west of where I grew up, which, at least for a kid like me, living in the little town of Scotia, might as well have been the other side of the moon for how accessible it was. But near Great Sacandaga Lake, you can find more than a few bodies of water. Lake George, which is a bit bigger and more popular with the tourists, is one of them. Lake Luzerne is another; it features a waterfall of such a gentle sloping grade that, as kids, we could whoop down it as if it were a slide under the watchful eyes of our mothers. But as a kid, Sacandaga was the only truly great lake in my mind, and the fact that it really had the word *great* in its name had nothing at all to do with it. Aside from being big, beautiful and not overly developed with mansions with lake views that most people could never hope to own themselves, Sacandaga had a good story attached to it, one that really captured my young imagination.

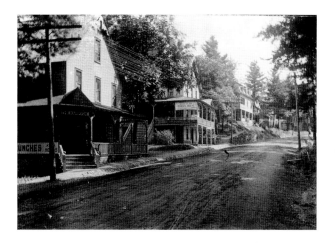

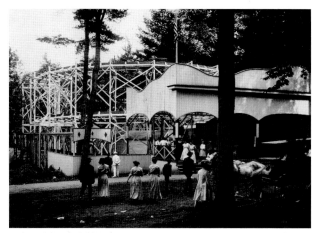

This page: Among the places lost in the creation of the Sacandaga Reservoir was Sacandaga Park, a late 1800s resort town and later amusement park. While the roller coasters, open air movie theater and "Sport Island" ended up burned and flooded, the railroad station that once served the park has survived. *Courtesy of the Library of Congress.*

Long before I ever dipped one dirty little toe into its waters, the lake did not exist. This is because the Great Sacandaga Lake is a man-made reservoir. In the 1920s, the Sacandaga River was dammed to help stop larger cities like Albany, located further downstream, from flooding annually. With the dam in place, the river turned into a lake, one that swallowed up several small towns that had been located within the valley. All in all, around 1,100 people were displaced by the creation of what was originally called the Sacandaga Reservoir—not a huge number when you consider how many other people and towns were able to flourish with the water under control. In the 1960s, the Sacandaga Reservoir was renamed Great Sacandaga Lake in the hopes that tourists would be more interested in going somewhere labeled "great."

I don't know how most tourists felt about Sacandaga. In my experience, most real tourists went to Lake George, and the Great Sacandaga Lake was more of a rustic playground for upstaters. But as a small child, I definitely believed in its greatness. The idea of an entire lake being created from nearly nothing, the water coming in and sweeping up towns (and maybe, just maybe, I figured at least a couple of people) was one that kindled the storytelling part of my brain in a way that I don't think anything else ever had before. Just as stunning to my young self was when I learned that some people had saved their homes before the flood, moving them to higher places where the lake couldn't claim them. The lakeside house of a family friend, where I spent most of my summers, was one of those homes that should have been lost when the lake was built. Sleeping out on the screened-in porch or climbing the rough-hewn farmhouse stairs to the weird little attic rooms we played in, it seemed unfathomable to me that somehow, people had once picked up this two-story white farmhouse and carried it to safety.

It was a magical story for a kid—one of those early moments when you realize that real life can be even more fascinating than make believe. But it was kind of a scary story for a kid, too. I would splash and laugh all day long in the lake, but some part of my mind was always thinking about houses beneath the waves. When storms came, the Great Sacandaga Lake would sometimes spit out strange things on the beach, rusted bits of things I could not name, old farming implements, funny-looking glass bottles. Remember, this was before the rise of the internet. There was no way for a kid with an overactive imagination to verify any of the stories a bemused uncle told them about the creation of the lake or to combat the increasingly outlandish stories we told each other.

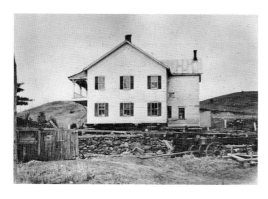

A farmhouse being moved before the lake could cover it. Ironically, many such homes were floated down rivers to save them from the waters that were coming. *Courtesy of the Library of Congress.*

As I got older and moved away from the area, I would, from time to time, come across someone who would mention a town lost beneath a lake. I always assumed they meant the towns that were lost to the creation of the Sacandaga Reservoir. In telling their story, if they mentioned the name of a different lake, in a different place, near where they had spent their childhood years, it was easy to pass off their memory as urban legend. They must have heard about Sacandaga and, in the way people do, changed the story with each retelling until it became a lake near where they had grown up—not a lie exactly, just the natural progression of a good story. Stories are always more interesting when you say you experienced something yourself rather than heard about it.

There are many sad truths you have to face as you grow up. Time really will not stop for you. You cannot eat nearly as much junk as you did as a kid without getting sick. Being an adult is not at all it's cracked up to be. For me, one of the saddest truths was learning that Great Sacandaga Lake was really not so special after all. What had seemed an amazing and incredible bit of unique history to me as a kid is actually a very commonplace event that played out time and time again in places all over the country. Whether it was done to stop flooding, create drinking water or generate electricity, there was a time that lakes were created just about everywhere, it seems, swallowing up little villages and towns as they went.

My childhood daydreams of fish swimming through grim abandoned homes sunk deep into murky water, I have discovered, are also not true. When New York State came in, buying land to make the lake, anything that had not been moved to higher ground was burned with methodical efficiency. Of course, deep down, I'm still that little girl imagining ghost stories while eating boxes of lake water–soaked Freihofer's cookies. Who's to say that the state demolished every house before finishing the dam—every single one? That seems unlikely, doesn't it?

Not every town in the coming chapters was sunk purposefully to create a lake, but they all ended with a watery demise. Too often, we underestimate the fickle nature of water. We relax near ocean waves, even knowing about rip tides and tsunamis. The same rains that break heat waves and grow crops can also cause floods.

Flagstaff, Maine

Flagstaff may be one of Maine's most famous lost villages. The small hamlet located in Somerset County got its name in 1775, when Benedict Arnold and his men paused there just long enough to plant a flag before going on their merry way to Quebec. By chance, Arnold planted this flag in a fertile floodplain along the Dead River at the base of the Bigelow Mountains. People soon found they could grow crops easily there, and lumber was, as expected, a plentiful resource.

Myles Standish, a descendant of the pilgrims and a military leader of the Plymouth Colony, built Flagstaff's gristmill and sawmill. They were powered by the rivers cutting through the area, and they served all of the nearby towns. The people of Flagstaff were not wealthy, but with thriving farmland and the mills they needed to process essential materials, they had an easier time than most. That's not to say that tragedy never struck the residents of Flagstaff, however. In 1831, the town flooded disastrously after a sudden spring thaw dumped a huge excess of snowmelt into the Dead River. The residents of Flagstaff had to flee their homes and all shelter at the home of John Berry, whose farmstead was located on the highest point in town. The flood happened so quickly and without warning that Isaiah Taylor had to save a bedridden neighbor by taking a boat into the log cabin where he was laid up with a broken leg and rowing him to safety.

In 1899, nearly one hundred miles south of Flagstaff, an electrical engineer named Walter Wyman and attorney Harvey Eaton were joining forces to create the Oakland Electric Company. At its start, it had one generator and powered streetlights for a town of just under one hundred people. But the diminutive start of the Oakland Electric Company belied greater things to come in its future. In a short amount of time, Wyman and Eaton were buying up other small electric companies and consolidating them into a statewide behemoth that came to be called the Central Maine Power Company. The company relied on small hydroelectric dams across

the state to create the power that was in increasingly high demand. Once the large mills that sprung up over the state during the Industrial Revolution signed on to get their power from Wyman's company, unimaginable wealth began to flow as freely as electricity.

Still, Wyman had a grander vision. He wanted to dam the Kennebec River where it met with the Dead River at a spot known as the Forks. Percival Baxter, who would go on to become Maine's fifty-third governor, fought the plan tooth and nail. He believed the state itself should be building dams and controlling the flow of water and electricity, not some private company. When it began to look as though the legislative opinion was not going to come down on his side, Baxter was able to push through a separate bill that would keep companies from producing electricity in Maine to sell outside the state. While most agreed with the bill because they thought Maine's resources should serve the people of Maine, Baxter's hope was that it would cripple the plans of the Central Maine Power Company. But even this was not enough to stop Wyman's big plans. Eventually, the state relented and agreed to let Wyman build his dam—but only on the condition that he would first buy all of the state-owned land that would be underwater once the dam was complete.

Wyman balked at the price the state quoted him for the properties and refused. But Walter Wyman was not so easily defeated. He quickly came up with an alternative plan. He could just as easily construct a dam at Long Falls on the Dead River, with no need to lease or buy anything from the state. The only thing in his way were two small towns: Flagstaff and Dead River.

Beginning in the 1920s, it became a common sight in Flagstaff to see men in suits knocking on doors and making offers on houses. The more people sold, the more pressure there was on the remaining residents to also sell their property and move out. But there were always those who continued to hold out hope for a change in plans. As more time went by and the threatened dam didn't appear, many grew used to the threat hanging over the heads and decided to wait to see what the future might hold. Even as their neighbors moved to other nearby towns on higher ground, like Eustis, there were those who thought the project would never actually come to fruition.

But by 1949, enough of the town was under control of the Central Maine Power Company that they sent crews out to burn the brush and forests surrounding Flagstaff. Then they laid waste to many of the homes the company had bought. The air, thick with black smoke from the burning, was one more incentive for the stragglers to move out. Some homeowners

decided to have their houses moved along with them. Larger city-owned buildings, like the brick schoolyard, were razed by bulldozers that were rented by the Central Maine Power Company. It was not only the then-current residents of Flagstaff who were forced to move, but the dead ones as well. Each grave in the Flagstaff Cemetery was excavated, and the remains were moved to a new plot in a cemetery in Eustis.

That year same year, over the July 4 holiday weekend, Flagstaff had its last hurrah. About twenty-five families were still holding out hope and clinging to their hometown. Reports say another three hundred former residents and curious onlookers came to the town-wide celebration. Reverend Arthur MacDougall Junior called it a "seeming burial." But overall, the party goers were in jovial moods, and there was fond reminiscing of the type you'd find at a large family reunion. While gray smoke of the burning forest rose over the party, everyone came together to share stories of the past.

When someone asked what would happen to the commemorative staff that had been placed where Benedict Arnold had raised the first flag over the area before there was a town, Postmaster Evan Leavitt said, "Why not leave it there? It will rise above the water."

In 1950, when the dam construction was finished and the area ready to be flooded, many homes still stood. As the flood waters rose, former residents crowded the banks of the rapidly emerging Flagstaff Lake to take pictures of their houses half covered by the water. It was an eerie sight that would stick with many for the rest of their lives.

With the creation of the dam at Long Falls, Flagstaff Lake, the largest man-made body of water in the state, was formed, and Maine's hydroelectric output increased many times over. Longtime Flagstaff resident Marilyn Rogers was quoted in her four-part series that was published in the *Town Line Newspaper* on the loss of Flagstaff, saying, "With the price of electricity climbing steadily, will someone please tell me how high is the price for this thing called progress?"

Main Street, Flagstaff, Maine, as seen in 1915. *Courtesy of the Library of Congress.*

Years later, the town of Flagstaff would prove to still have some life left in it. During an unusually dry February in 1979, Flagstaff Lake would shrink back down to nearly the same size as it had been when

it was the Dead River. The skeleton of the town of Flagstaff rose from its depths. The town's roadways, coated generously with tar, as had been the practice back in the day, could still be seen, though they were thickly coated with mud. Cellar holes dotted the landscape, with concrete steps and the shattered foundations of brick chimneys sticking up here and there like broken teeth. The old-fashioned gas pumps that once held places outside of Ame's General Store were still intact, if more than a little rusted.

Among the surprises—as if the reemergence of the town were not surprising enough—were the remains of a Delta F-102, complete with six Falcon missiles and twenty-four intact rockets. The plane had crashed over Flagstaff Lake in 1959, when a radar training mission went wrong. The pilot of the Delta F-102 had never been recovered, and there was hope that with the plane unearthed from the depths of the lake, the military might be able to give his remains to his family. Sadly, the plane was empty, and the pilot's body has never been found.

THE QUABBIN RESERVOIR, MASSACHUSETTS

With an area of thirty-nine square miles and with 412 billion gallons of water, the Quabbin Reservoir is the largest in-land body of water in Massachusetts and one of the largest man-made reservoirs for drinking water in the entire world. And it should go without saying that in order to create such a massive supply of water, more than just a few people needed to be displaced. The Quabbin actually rests over the remains of many once thriving villages and towns that were called home by thousands of people.

The current location of the Quabbin Reservoir was once called the Swift River Valley. It was settled as early as the 1700s, and in time, many small villages and towns began to flourish there. There was talk as early as 1922 about the valley being flooded to create drinking water for the rapidly growing eastern portion of the state, but most residents never took it very seriously. Nearly 3,000 people lived and worked in the valley, with homes, stores, churches, schools and everything else that came with having that many people in one area. Aside from the thousands of people who would need to be displaced, there were another 7,613 bodies buried in the area cemeteries—some dating back to the town's founding in the 1700s—that would need to be dug up and reburied elsewhere on higher ground. While smaller projects for drinking water or to create electricity were springing up

around New England at this time, the residents of the Swift River Valley felt secure that the scope of the proposed reservoir was just too big, too ambitious, to be of any real concern for them.

In 1927, things took a sudden and more serious turn. The Swift River Act was passed, giving the state the ability to take all of the land in the valley under eminent domain. Residents who owned land that would be lost to the reservoir would receive $108 per acre. They were given the deadline of April 27, 1938, to move themselves, their families, and whatever belongings they wanted out of the path of the future lake. Some made plans to leave immediately. Others decided to take things slow and see if, perhaps, their homes would be saved. Among the many who were impacted by the decision, there was great bitterness and anger at the commission that had decided their homes and their way of life should be sacrificed so that the city of Boston could thrive. Business owners felt especially cheated. The $108 per acre didn't compensate those who rented storefronts, and it didn't account for the value of the ventures they had to shutter and move. Families who had lived in the Swift River Valley for generations, oftentimes in the same family home, also felt cheated. The per-acre allotment didn't consider the value of their homes or the length of time their families had been in service to the community.

While residents lamented the loss of their towns, the Metropolitan District Water Supply Commission went straight to work, tearing those same towns down. Teams of men cleared the area of brush and razed homes, one by one, as families left. In a sad bit of irony, many of the workers who did the hard tasks of moving the dead and demolishing homes were the same residents who were being displaced by the reservoir. This was, after all, the Great Depression. People took whatever jobs they could, even if those jobs involved tearing down a neighbor's home or speeding up the demise of the town they lived in. Eight railway stations were torn down, thirty-six miles of state highways were redirected and any items that were left behind in homes or stores were auctioned off to the highest bidder. Ultimately, everything in the towns of Dana, Doubleday, Smith's Village, Enfield, Millington, Bobbinville, Prescott, North Prescott, Greenwich, North Dana and Greenwich Village were all sacrificed to create the Quabbin Reservoir.

One of the grislier jobs in the creation of the Quabbin Reservoir was cataloguing and moving the many thousands of bodies that had been buried across thirty-four cemeteries in the Swift River Valley. Each body was carefully plotted on a map before the tombstone and grave were photographed. As

each body was dug up, the dirt taken from the grave was sifted to make sure that no personal items were left behind. Families of the deceased were given two choices: the remains could be moved free of charge to the newly created Quabbin Park Cemetery or the state could give them thirty-five dollars, and the family could have the bodies buried elsewhere. The overwhelming majority chose to have their family members brought to the Quabbin Park Cemetery, an eighty-two-acre expanse of former farmland. Aside from the bodies of the disturbed dead, the commission also moved all war memorials and markers from the Swift River Valley towns to the new cemetery.

When April 27, 1938, rolled around, residents of the towns that would be disincorporated at the stroke of midnight came together at Enfield's Town Hall. Those with tickets they had purchased beforehand danced the night away inside. Those without tickets gathered on the front lawn and did some dancing of their own. The next morning, the people who were left began to leave for good. A hurricane would slow down the leaving process for a few stragglers, but by the end of 1938, the area was completely cleared. The damming of the river was done in stages. It would take years for the Quabbin Reservoir to reach its full height.

Today, the Quabbin Reservoir is a beautiful lake located about seventy miles west of Boston. It provides clean water for the city of Boston and around fifty other eastern Massachusetts communities. Even today, there are still hints of the four towns that disappeared beneath its surface. Some of the original paved roads remain in various states of disrepair, forging right up to the water's edge but going nowhere. The town common of Dana, Massachusetts, was just high enough that hikers can still visit it and climb

One of the photographs taken of each grave before the body was disinterred and moved to be buried again in a new cemetery on higher ground. *Photograph by Charles B. Chetwynd for the Metropolitan District Water Supply Commission.*

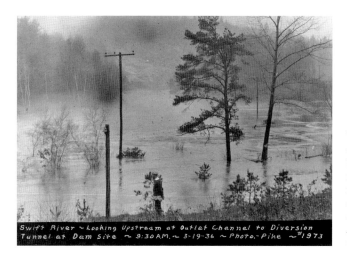

Swift River ~ Looking Upstream at Outlet Channel to Diversion Tunnel at Dam Site ~ 9:30 A.M. ~ 3-19-36 ~ Photo.- Pike ~ #1973

The town of Enfield celebrated the night before the town was flooded and lost forever. *Photograph by Stuart Pike for the Metropolitan District Water Supply Commission.*

around the cellar holes left over from the town's church, it's school and some shops. A memorial sits at this site, which has been placed in the National Register of Historic Places. Plaques have been added over the years that show images of the homes and buildings that once stood there. In this same spot, you'll also find another tribute to the lost towns. Erected in 1996, when some surviving Swift River Valley residents gathered for a reunion, the large carved stone says it serves as a monument "to all those who sacrificed their homes and way of life."

The high cost paid by the Swift River Valley residents in the creation of the Quabbin Reservoir is also memorialized in another way. When Memorial Day remembrances are held at the Quabbin Park Cemetery, it is now a tradition that the sacrifice made by the former residents is honored along with the veterans who gave up their lives in service to this country.

NAPATREE POINT, RHODE ISLAND

Readers of a book about historic villages turned modern-day ghost towns probably don't expect to see Taylor Swift, Henry Ford, Conan O'Brien, Clark Gable or Albert Einstein mentioned. Readers of any book would probably be surprised to learn that those people all have something in common. Each of them—and more celebrities than could be listed here— have been or are summer residents of Watch Hill, Rhode Island. While Newport, Rhode Island, might be more well known to the casual tourist,

those in the know point to Watch Hill as the true enclave of the fabulously rich and famous. Seen from above, Watch Hill, a small exclusive village that's part of Westerly, sits about as far southwest on the coast of Rhode Island as you can go. If you look very closely, you'll see that the town looks like it has a tiny little tail flaring out into the Atlantic Ocean. That tail is Napatree Point.

Unlike other towns in this section, Napatree Point, Rhode Island, wasn't sacrificed so that other towns could have drinking water or electricity. Really, it barely had much of a chance at all to be a town before the sea claimed it. The name alone should have been a warning of what was to come. Its name means "neck of woods," because Napatree Point, a sandy spit of land formed by the relentless pull of the tides, was once covered in a thick, dense forest. But in 1815, a gale stripped the point of all of the trees it had been named for. To be fair, this was not your typical ocean storm. The Great September Gale of 1815 is, to this day, one of the five largest hurricanes (the term *hurricane* had not yet been invented in 1815; hence, it's called a gale) to ever hit New England. More than five hundred homes in Rhode Island were obliterated by that early fall storm. The winds were so strong, dozens of ships were picked up and deposited on the streets of Providence, and many people in Rhode Island lost their homes and their lives.

That storm was probably the most exciting thing to happen on Napatree Point until 1898, when the United States government bought sixty acres of the spit to build a military complex on. This was, after all, the very start of the Spanish-American War, and there were serious fears about New York City being attacked by sea. The federal government was building so many forts at this time, stretching from Galveston, Texas, to the northern reaches of Maine, that the period has even been given its own name. The Endicott Period began when a joint committee of civilians and representatives of the army and navy was formed under the leadership of William Endicott. At this board's recommendation, twenty-nine seaside complexes were built in the space of only a few years at the cost of $127 million (which would be somewhere north of $3.75 billion in today's money).

Napatree Point was ideally located to serve as a lookout point for the eastern entrance of Long Island Sound. Historical evidence shows that even the Native Narragansett tribe had used the point to watch for enemies long before the United States even existed. While the landform might not have been terribly impressive in and of itself, it offered stunning open views of the Rhode Island coastline, Block Island Montauk Point, Long Island and even points in Connecticut.

Within two years, Fort Mansfield was constructed. Napatree Point would no longer just be a place to watch for danger, it had become a place to stop danger in its tracks. The main feature of Fort Mansfield was anti-ship artillery and fixed gun stations. The complex, which was considered a small open-plan post for one company of men, also featured a six-bed hospital, three homes for officers, a one-hundred-man barracks, temporary housing for another thirty enlisted men, a guard house, an administrative building and a few smaller structures for storage and other support. All of the buildings were designed with a Colonial Revival aesthetic, which featured none of the gingerbread trim seen in many other houses of the era, but they still had the rest of the Victorian charm.

In 1907, a mock battle was held at Fort Mansfield. Summer residents of Watch Hill came out for the day to watch the maneuvers, parking their cars along the road leading to the fort and picnicking on the nearby beaches. They got a different kind of show than they bargained for. This is how the battle went according to a popular naval magazine called *Seaside Topics*: "Uncle Sam let loose the dogs of war around Watch Hill this week, and they did some furious barking. Fort Mansfield was the bone they wanted to chaw, and according to the rules of the war games, they succeeded."

That's right; after half a dozen years guarding the Long Island Sound, it was discovered that a fatal flaw existed at Fort Mansfield. If an attack had ever actually been waged, all of the guns and all of the well-trained military personnel wouldn't have made a lick of difference. When the mock battle commenced, it was discovered that to the east of Fort Mansfield, there existed a dead zone, a wide swath of sea that the weapons at the fort just couldn't reach. That exact section of water was not only impossible for them to hit, but it was also deep enough that a battleship could park itself there while never being endangered. The fort could no more protect New York City than it could have saved itself from being destroyed if a real battle had ever occurred.

Shortly after the military left, leaving just eight men to act as caretakers where well over one hundred had been expected to live and work. By 1917, all of the guns had been removed and sent to other forts, where they hopefully had a more accurate reach. In 1926, nearly all of the buildings were torn down, and the entire parcel was put up for sale. Just as quickly, it was bought by a private developer from New York for $365,000.

This developer had made their name building summer resorts. But that was not at all the proposed plan for the point. Instead, they planned to build a brand-new kind of community, a complete town with 674 tiny

residential lots, in place of the military complex. At this point, the wealthy and well-to-do residents of Watch Hill became more than a little alarmed. Many felt very strongly that so many small houses out on Napatree Point would ruin the exclusivity of their affluent vacation spot and cause the value of their mansions to plummet. The neighbors mobilized against the project and began to fight the development at every turn. The residents of Watch Hill would breathe a sigh of relief when the developer had a change of fortune, and the property was foreclosed on for an unpaid mortgage in 1931.

In one final fatal twist of bad luck, Napatree Point was bombarded by yet another unprecedented storm. The hurricane of 1938 was another whopper. While the gale of 1815 yanked trees from their roots, the 1938 hurricane swept every single one of the little houses the developer from New York had begun to build, along with a handful of the more well-to-do summer homes that had predated them, out into the sea. Fifteen people died on Napatree Point on the day of the storm, and not a single house was left. Also gone was Napatree Point. The storm surge was so strong that it changed the geography itself. In the span of one hurricane, Napatree Point became Sandy Point, a thirty-five-acre island that is partially located in Rhode Island and partially in Connecticut. It's been a nature preserve

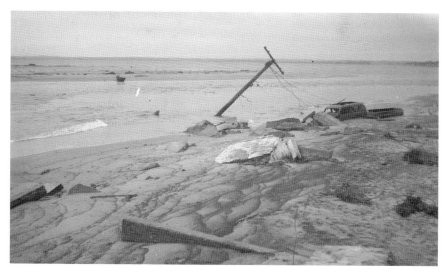

This Department of Defense photograph shows the devastation wrought on Napatree Point by the hurricane in 1938. *Courtesy of the Library of Congress.*

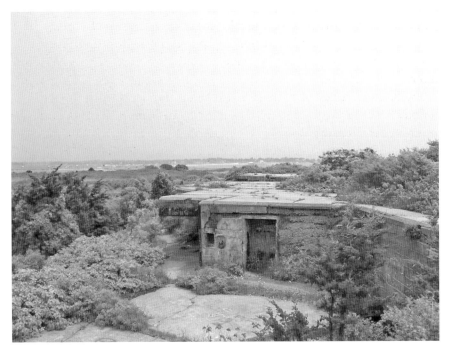

What remains today of Fort Mansfield. *Photograph by Renee Mallett.*

since the 1980s. While you can find plenty of shoreline birds and horseshoe crabs on Sandy Point, you can't see any sign of the village that had just started to be built before being lost for good. On the mainland, you can still see three concrete gun emplacements, and a small network of tunnels are most of what remains of Fort Mansfield.

UNITY SPRINGS, NEW HAMPSHIRE

Lake Sunapee, the fifth-largest lake in New Hampshire, is a year-round tourist destination. In the summer, aside from swimming and boating, you can visit the League of New Hampshire Craftsmen Fair to see handcrafted goods from over two hundred artisans or go visit any one of the three lighthouses on the lake. In the winter, Mount Sunapee offers skiing and snowboarding. But in the late 1800s, people came to the Sunapee area to enjoy a much different water-related attraction.

A few miles to the west of the lake, there exist a series of springs. The belief in the medicinal value of mineral springs dates back to the beginning of known human history. But the popularity of "taking the waters" (as it was known at the time) really exploded in the late Victorian era. The combination of a wealthier middle class, thanks to the Industrial Revolution, and the time period's belief in pseudoscientific health cures made mineral spas a suddenly trendy retreat. Resorts were increasingly built around mineral springs so guests could rest, relax and bathe in or drink the waters.

Unity Springs to the west of New Hampshire's Lake Sunapee was one of these suddenly in-demand locales. Located about three miles south of present-day Newport, Unity Springs offered ten mineral springs and a choice of two hotels to stay in while guests visited them. The water had such a high concentration of iron salts that, for a while, they were known as the Iron Springs. The Unitoga Springs House, the most sought-after resort in town, had sixty rooms, was open to reservations from both men and women and had full access to the springs.

For reasons now lost to history, the heyday of the hotel and the small resort town that grew around it was short. Unitoga Springs House changed hands several times in just a short period. It was bought by Wyman Henry Merritt in the spring of 1874, just to be sold a year later to L.R. Miller. By 1876, it had changed hands again, this time to a beverage distributer that bottled up the naturally occurring spring water. It was marketed as both a healthy spring water and a ginger ale. But even with the added revenue stream from the summer beverages, Moses Fairbanks & Co. were looking to lease the property to someone else as early as 1879.

In 1881, the entire city of Unity Springs was up for sale. Moses Fairbanks & Co. listed the seventy acres that made up the springs and the village at a discounted price and offered to subdivide the resort if that was the only way to get rid of it.

In 1889, a pair of brothers from nearby Newport took a gamble on the offer. They bought the property outright. But the Upton brothers would fair no better than all the previous owners. Within three years, the resort burned to the ground, and no one was willing to try to restart the village or the hotel, so it was never rebuilt. Despite the popularity of the town and the hotels, few people outside the area remember the time when a small spring of water was a larger attraction than the lake nearby.

DAMN YANKEES

There's some debate about the origins of the word *Yankee* and how it came to be applied to New Englanders. Some sources claim it was a mispronunciation of the Natives when trying to describe the English. Others say that it came from the Dutch. Either way, it is found in use as early as the 1680s, and even then, it was not being used as a particularly complimentary term. In its earliest usage a Yankee was someone who made tricky deals and had questionable—if not quite illegal—business practices.

It was during the French and Indian War that the British began to use it in earnest as an insult to the colonists. Yankee Doodle was a derogatory term the British used to describe those they saw as foolish colonists who were unsophisticated and totally removed from the worldly English social mores and trends. A Yankee Doodle would know no better than to stick a cheap feather in his hat and think that was equal to the extremely fabulous and fabulously expensive wig known as a macaroni. (You didn't think those "Yankee Doodle Dandy" lyrics were about pasta, did you?) The macaroni was not so much a fashion trend as a line in the sand between being fashionable and being so over the top, effeminate and expensive that only a certain level of ultrawealthy elite would wear it. If you compared a fashionable wig of the times to a pair of stylish high heels today, the macaroni would be a pair of sky-high Louboutin heels walking down the Paris Fashion Week runways.

So, yes, it's sad to say that "Yankee Doodle Dandy," beloved by young children across America, started as taunt against the colony troops. Things changed in more ways than one on April 19, 1775. On that day, the Battles

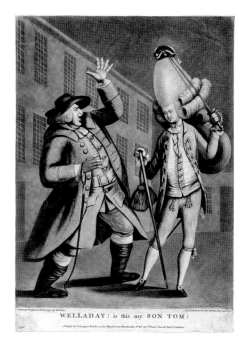

WELLADAY! is this my SON TOM!

The "macaroni"-style wig, quite literally the height of fashion. *Illustration by Carington Bowles, 1774.*

of Lexington and Concord took place in the Massachusetts Bay Colony—the first skirmishes of the Revolutionary War. As the American militia forces drove British troops back into Boston, they began to play "Yankee Doodle Dandy," taking the former insult and making it their own.

In time, *Yankee* became a term used by people in the other parts of the United States to describe those people who resided in what were the original thirteen colonies. Internationally, *Yankee* or *Yank* is usually meant to describe any American. The children's author E.B. White, who penned such beloved books as *Stuart Little* and *Charlotte's Web*, probably explained it best when he wrote:

> *To foreigners, a Yankee is an American.*
> *To Americans, a Yankee is a Northerner.*
> *To Northerners, a Yankee is an Easterner.*
> *To Easterners, a Yankee is a New Englander.*
> *To New Englanders, a Yankee is a Vermonter.*
> *And in Vermont, a Yankee is somebody who eats pie for breakfast.*

The term "Damn Yankee" was most often used by Southerners during and after the Civil War, usually as a complaint about Northerners who

traveled or moved south. This proves nothing but that everything always comes full circle and that if an insult can become an adopted nickname, that nickname can become an insult again.

But even that insult is, for many New Englanders, a source of pride. A damn Yankee is stubborn, practical, down to earth, set in their ways and possibly more than just a little odd. And that is exactly how most damn Yankees proudly describe themselves. This streak of individualism often serves Yankees well, thank you very much. But from time to time, it has also resulted in towns rising up from nothing for the strangest of reasons and then being abandoned for reasons that are just as curious.

And of course, the next step beyond a damn Yankee is a damned Yankee. You can't talk about abandoned villages without a few supernatural tales of yore working their way in. Some stories of New England's ghost towns have only survived thanks to the scandalous, the criminal and the downright spooky residents who once lived in them.

Gosport, Maine…and New Hampshire

Forget about Democrat or Republican, dog people or cat people, people who think *Die Hard* is a Christmas movie and those that don't. There are really only two kinds of people in the world: those who are Shoalers at heart and those who are not.

The shoals in question are, of course, the Isles of Shoals, a series of small islands—many more like small piles of rock rather than proper islands—located just six to ten miles off the coast directly east of Portsmouth, New Hampshire. Half of the islands are considered to be part of New Hampshire, while the other half belong to Maine—though even that gets complicated from time to time. Today, the islands are home to a marine laboratory, a few select homes and the Oceanic Hotel and Conference Center, once a grand dame of hotels that is now used as a summer retreat by the Unitarian Church. For such a remote and lightly settled community, the islands have a wealth of history, legends, lore and, yes, abandoned ghost towns. They could fill more than a single book all on their own. In modern times, during good weather in the summer months, visitors can take the Isles of Shoals Steamship to and from Star Island for day trips. When the Thomas Leighton Ferry pulls up to the Star Island Dock and discharges its passengers, the two types of people, Shoalers and non-Shoalers, are

instantly apparent. Some come off that ship as if they are coming home, a look of wonder on their faces whether it is their first visit or one they've made a dozen or more times over the years. Others, you can tell just don't feel the pull of this place the way the others do. They look at the small islands and see desolation, not the rich history and charm of them. It's a history that dates back to before the New World was "discovered" by European settlers and culminates in the abandonment and rebirth of a single town.

Some sources say that the Native tribes that called the mainland home refused to have anything to do with the Isles of Shoals, either because the islands were too sacred or too cursed to be trifled with. These ideas seemed to be linked more to myth than fact, though the Native Americans did both love and fear the Isles of Shoals. Fishing was plentiful, and the islands were relied on and well visited for this very necessary resource. But darker stories were told. The unforgiving landscape almost invites legends to be made up about the islands. This is in stark contrast to the glowing reviews that were given to the islands by Captain Smith, the first recorded European explorer to come across them. In fine old-world tradition, Captain Smith would name them Smyth's Isles after himself, and of them, he would later write, "And of all the four parts of the world that I have yet seen not inhabited…I would rather live here than anywhere: and if it did not maintain itself, were we but once indifferently well fitted, let us starve."

If it seems strange that the Native population and Captain Smith had such drastically different feelings about the Shoals, it's worth noting that the famed explorer only ever passed by the small group of islands. He did not stop there long enough to even land on them. When King James split up parts of New England, Captain Smith would get his wish. The monarch granted Smith the very same islands he had named for himself. But in an odd stroke of irony, Smith would never see the Isles of Shoals again and died without ever having set foot on them.

The Isles of Shoals may have never been home to Captain Smith, but they did serve all kinds of other purposes over the years. The harbor between the islands was a popular refuge; fishing boats made the trip out to the islands year after year; and a few hardy souls did create more permanent settlements as time went by. Most of these could not properly be called towns. A family of fisherman might stop by for a year or two, build a group of homes for sons and brothers and then move on. The first real town of note was Apledoore, created on Hog Island. At ninety-five acres, Hog Island (known as Appledore today) is the largest of the Isles of Shoals. It was home

to a church as early as 1640, and the town of Apledoore grew up around it. The Massachusetts Bay Colony officially incorporated the village in 1661. In 1665, the Shoalers, already proving to be quarrelsome, decided to change the town name to Iles of Shoales.

Although Maine began as its own colony, it was considered a district of Massachusetts from 1650 to 1820. Massachusetts, unable to get the residents of Hog Island to take any part in colony life, then decided to tax them. In response the residents, some forty or so families, packed up their belongings, rowed across the harbor and re-created their village on Star Island in tax-free New Hampshire. Because lumber was sold at such a premium on the shoals, which are so low and windy that few trees can cling to the rocks, the Gosport residents even pulled their homes down, board by board, to bring with them and rebuild as they were on the other island. Though mostly abandoned, what small buildings and few people remained in Apledoore/Iles of Shoales were annexed to the town of Kittery, Maine.

Although they were not a terribly religious group, a church, which doubled as a meeting house, was one of the first structures built in the Star Island version of Iles of Shoales. The wood-framed building was said to have been made from lumber salvaged from a Spanish vessel that was shipwrecked in the small archipelago. As New Hampshirians, the Shoalers on Star Island did pretty well for themselves. Cod were the main fish that they were pulling from the sea, and they were able to sell them in Portsmouth and beyond for a good price. Even more people moved to Star Island to take up residence in the relocated town that then went by the name of Gosport. A bakery, a brewery and several other shops and businesses sprang up. The sudden human habitation came at a price. With most of the trees felled for lumber and grazing animals covering Star Island, the already rocky land became even less inhabitable. The population took a small hit as the land suffered, but overall, most of the Shoalers were fishermen, and the lack of farmland didn't mean much to them. Most of the people who chose to live the kind of hardscrabble life the islands provided were there for more stubborn reasons.

As the years passed, the Shoalers continued to think of themselves more and more as just that. They were island people, not colonists. In 1732, a Harvard-educated minister named Reverend John Tucke moved to Gosport, intent on saving the Shoaler's souls. He had been offered a loftier and much better paid position at a church in Chester, New Hampshire, but had turned the post down. Reverend Tucke had visited Gosport the year before and had been shocked at the lives of the Shoalers. He found them

The original wooden-framed church on Star Island was burned in 1790 by fisherman looking for timber for a fire. The stone chapel that still stands today was built in 1800. *Photograph by Renee Mallett.*

to be utterly unaware or in contempt of the regular manners expected on the mainland. Reverend Tucke also related that the Gosport residents were as hardworking as they were hard drinking.

At the time of his arrival, it is unlikely that Reverend Tucke would have ever guessed that he would live the rest of his life on Star Island and become a Shoaler in his own right. In his time, he served as the island's minister, its doctor, a judge, a justice of the peace and a teacher to the few children who grew up in Gosport. Reverend Tucke convinced the residents of Gosport to hold town meetings, and he started the practice of keeping town records, written in his own neat handwriting.

John Tucke died in Gosport on August 12, 1773, at the ripe old age of seventy-two. His beloved wife had died just a few months before him. The couple had nearly a dozen children while living in Gosport, but the rough and unpredictable life of a Shoaler had taken its toll. Only two or three of the Tucke children survived through infancy.

In some ways, it is as if the death of Reverend John Tucke had been a sign of the coming death of Gosport. The Revolutionary War would cause an evacuation of the islands. The Revolutionaries had some concerns about the political leanings of the Shoalers and used the excuse that they would be unable to protect the islands in a war in order to scatter the headstrong population among the mainland population. The population dropped from well over two hundred to just forty-four rugged individualists because of the evacuation.

Things probably would have continued in this fashion, with the shoals an odd refuge for just a small number of eccentrics, the town of Gosport at the center of them, but changes were coming to these small islands that were larger than anyone could have anticipated. A lighthouse keeper named Thomas Laighton would buy Appledore Island and build a grand hotel there. Laighton's daughter Celia Thaxter, a famous writer and poet, would publish a memoir about growing up on the Isles of Shoals, which helped catapult the hotel to fame. Between her connections and the beauty of the shoals in general, the hotel attracted famous writers and artists from around the world.

At the same time that Appledore was becoming increasingly popular, over on Star Island, the town of Gosport was becoming more and more of a ghost town as each year passed. But Thomas Laighton and his hotel had given the town a roadmap on how to keep the island going. John Poore built a competing hotel on Star Island, which he named the Atlantic House, reusing timber and supplies from the abandoned Gosport buildings. The

Left: In 1914, descendants of John Tucke, in collaboration with the New Hampshire Historical Society, would build a memorial for the reverend on Star Island. The dedication for the memorial and an address on Captain Smith were collected in this book for the event. *From the collection of Renee Mallett.*

Below: From the interior of the memorial book, an image of the forty-six-and-a-half-foot-tall obelisk memorial and gravestone for Reverend Tucke. It is the largest gravestone in the state of New Hampshire. *From the collection of Renee Mallett.*

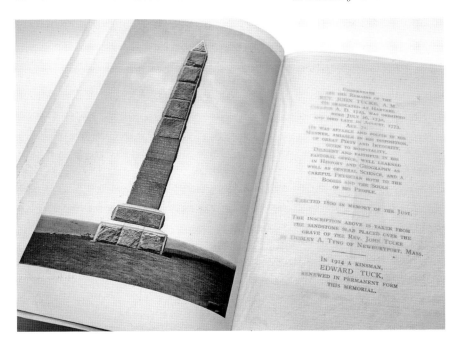

An 1873 first-edition copy of Celia Thaxter's popular book *Among the Isles of Shoals*. The book and Thaxter's reputation as a poet of note helped make the islands a popular destination for writers and artists. *From the collection of Renee Mallett.*

hotel did attract a good number of visitors, but it burned in 1875, just a few short years after it was built. Undeterred, Poore combined several of the last-remaining Gosport buildings into a new Oceanic Hotel. In 1914, Thomas Laighton's hotel on Appledore Island would burn completely to the ground, along with the cottage his daughter Celia lived in for most of her adult life. It was not rebuilt. But the Oceanic Hotel survives to this day on Star Island. During modern work on the Oceanic, a metal bar was found running underneath part of the structure, showing how a Gosport house was lifted from its foundations and moved to become part of the Oceanic Hotel. The threat of fire remains as serious as it was in the past; cigarettes and candles are expressly forbidden across most of the island.

In modern times, the Isles of Shoals may be the most uninhabited they ever have been. Lunging Island is privately owned, and White Island features one of only two lighthouses on the New Hampshire coast, but it's fully automated now. Appledore Island is owned by the Star Island Corporation. Although it is the largest of the Isles of Shoals, most of the buildings on it have been lost over the years to weather and fire. It is the home of the Isles of Shoals Marine Laboratory, which operates as a collaborative effort between the University of New Hampshire and Cornell University. The Star Island Corporation also, as you can probably guess, owns Star Island. Gosport, as a town, is gone from Star Island, but it is far from forgotten. Part of the great appeal of Star Island is how steeped in history everything is. Every storm or high tide seems to unearth some small bit of the past. The Oceanic Hotel is still in operation, although it is not quite the grand dame hotel John Poore had imagined when he built it. Today, it's a conference center for a series of summer retreats run every year by the Universalist Unitarian Church. It is kept, in as many ways as possible, just as it was during its heyday. While guests come for weeklong retreats in painting, art, yoga and other exploratory activities, they eat family-style meals in the sprawling dining room, have services in

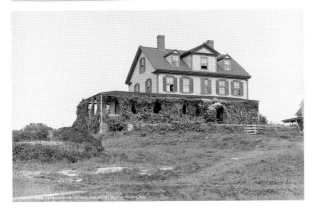

Top and middle: The interior and exterior of the program and dance card from the 1901 Employee Ball at the Oceanic Hotel. *From the collection of Renee Mallett.*

Bottom: Celia Thaxter's cottage, where she lived for most of her life. It burned, along with her father's hotel, in 1914. *Courtesy of the Library of Congress.*

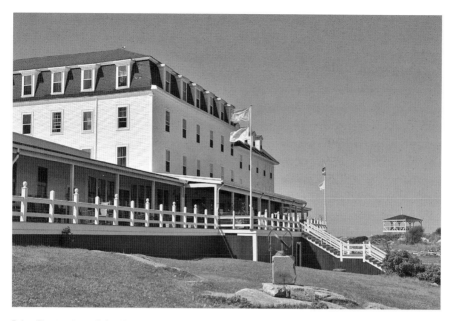

John Poore created the Oceanic Hotel by combining several buildings that still remained from the abandoned town of Gosport. *Photograph by Renee Mallett.*

the 150-year-old stone church and duck seagulls and poison ivy, just as the Shoalers of years past did before them. Day trippers are welcome to the island, as long as the boats from the Isles of Shoals Steamship Company are running. In the winter, a single caretaker lives on Star Island, keeping watch over the hotel.

Glastenbury, Vermont

Jeff Foxworthy built a comedy career for himself that began with the simple phrase, "You might be a red-neck if." The New England version of this joke would probably be, "You might be a Yankee if…you live in Glastenbury." That's because it takes a certain kind of New England stubbornness to continue to live in a town years and years after it becomes a ghost town.

Some would say that Glastenbury, Vermont, was marked to be abandoned right from the start. Its history is long and marked by an overall failure to thrive. The town certainly started off on the right foot. It was chartered by New Hampshire governor Benning Wentworth in 1761 and named for a

much more auspicious town in England. Legends say that Glastonbury—that is, the English Glastonbury—is the true location of Camelot of King Arthur fame and that Joseph of Arimathea brought the Holy Grail there and possibly built a church while he was at it. Maybe the problem is that Glastonbury, England, has used up all the good fortune—so much so that there is none left for the town of Glastenbury, Vermont.

Originally imagined as an agricultural community, Glastonbury revealed that its location, perched on a rocky mountain, and weather, cold with a short growing season, did not make that likely to be a successful way of life. A few folks seemed determined to make things work, and when the first federal census was taken in 1791, six families, a total of thirty-four people, made up the entirety of the village. By 1834, there were still around the same number of people trying to make a go of things. That same year, the town was officially incorporated. By 1840, Glastenbury managed to top a fifty-person population, with most of the residents still eking out if not a living, at least an existence with their small, family-run homestead farms. If the town was known for anything, it was for the copious amounts of maple syrup it produced every year, with some sources saying Glastenbury residents tapped the trees to create more than six hundred pounds of the sweet sugary condiment each season.

Glastenbury's only other claim to fame leaned more toward infamy than anything else. The Glastenbury Mountain Man, a cave-dwelling giant of a man who lived in the woods surrounding the town, was well known to everyone in the surrounding area. He was said to wear a long, dirty coat and, when coming across the curious, would wave a pistol wildly around his head to scare them off. When he came across women, the Glastenbury Mountain Man would open his coat like a modern-day flasher and expose his grimy naked body underneath.

The high point in the history of Glastenbury came just after the Civil War. In the neighboring town of Shaftsbury, a blacksmith by the name of Henry Burden was in desperate need of charcoal. The charred wood, turned nearly pure carbon, could heat very steadily and to very high temperatures, making it ideal for smelting iron. With so few residents and a nearly insatiable need to find some way of making money, Glastenbury seemed the ideal way to satisfy the need for charcoal. Glastenbury residents would chop down the surrounding forests and burn the wood, usually during the cold winter months, in large pits, where they were able to keep very little oxygen from fanning the flames. This stifled kind of heat, which kept true flames from eating through the wood, produced the best charcoal. From

there, the charcoal would be loaded onto wagons and brought to Shaftsbury. Henry Burden and a group of investors who bought several square miles of Glastenbury to build kilns for producing the charcoal in an even faster and better controlled environment changed the course of the town's fortunes—at least for a little while.

It may not seem like this would be the thing to spark a true town into existence, but charcoal was the most profitable endeavor in the history of Glastenbury. At the heights of production, the town was producing a whopping thirty thousand bushels of charcoal, mostly for use by the iron smelters located in the villages around it. The Glastenbury residents shipped the charcoal and some lumber in wide wagons that made the trip from the town to the surrounding communities in almost a nonstop circle. Transportation to and from the mountain on which the community was located became such a hot topic that the Vermont legislature would approve a charter for the Glastenbury Plank Road in 1849. The proposal was to create a road solely for hauling timber out of Glastenbury, but that was not how it got named the Plank Road. This many-miles-long road was planned to be made of planks. It was not just to ease the transport of the lumber; it was made of lumber as well. Luckily, a group on investors arrived with plans to build a railroad before any work could begin on the wooden road.

The unwieldly named Bennington and Glastenbury Railroad, Mining and Manufacturing Company was created in 1855 by R.C. Root, John Harper and Samuel H. Cornell of New York City. One of the first big projects of the company was to build a large sawmill. Next, they needed a way to transport the lumber produced by the sawmill to places around the country that didn't involve the costly and tedious construction of a bound-to-be-short-lived wooden plank road. It was thought by most, at first, that the train was a boondoggle. The land near Glastenbury was too steep and uneven to ever build a usable track. But the company had mortgaged all the timberlands it owned in the area in order to raise the capital to get the trains rolling. Failure was not an option. Skilled engineers from around the country were brought in to figure out how to make it work. It took several years of planning and eight months of building, but in 1872, the trains began to run. This train still holds the record for being the steepest track ever built in the United States. The elevation of the train changed by 1,200 feet in just the first eight miles of track.

By 1880, the prosperity of the town had changed for the better. Residents may not have been living a life of luxury, high on the hog, but they were no

longer struggling to just survive. The population topped 241 and could then support a blacksmith of its own along with several shops.

The hunger for charcoal and lumber was also Glastenbury's undoing. The sawmill owned by the Bennington and Glastenbury Railroad, Mining and Manufacturing Company had been cutting a reported one thousand board feet an hour, and the charcoal operations had burned through wood for many years. In 1888, a blizzard stopped the railroad for three months. By March 1889, everyone had to face the harsh truth that it wasn't just weather that had caused the trains to sit in the depot for so long. Over a relatively short period of time, the residents of Glastenbury had more or less burned or felled every tree of any size. The kilns stopped burning, the sawmill had nothing to cut and things went back to more or less the way they were before the railroad came. In 1890, the bank foreclosed on the railroad and the land that had been mortgaged to create it.

Townsfolk looked for new ways to keep the village going. For a while, they turned to fern harvesting. It might sound like a silly choice to our modern sensibilities, but it was actually a shrewd decision on the part of the people of Glastenbury. Fiddleheads, the young curled shoots of the fern before the frond opens fully to its frothy heights, are edible. Today, they can even be considered something of a delicacy with the seasonally available greens going for ten to fifteen dollars a pound at some farmers' markets. Once the fiddlehead season had passed, the fronds could still be harvested and sold to florists as additions to floral arrangements. There were several largescale commercial fern companies in the late 1800s and the early 1900s in Vermont. The dark, damp soil of the state meant there was a bumper crop of ferns growing naturally, and if they were harvested correctly, the same fern could produce something that could sold again and again for many years.

The M.I. Ackert Fern Company was a powerhouse in Vermont. It had a large facility right next to the train depot in Rutland, where it warehoused, packaged and redistributed ferns gathered from all around the state to businesses across the country. In more modern times, the company still existed and had diversified its dealings to include collecting and selling pinecones—at one point, becoming the leading pinecone supplier in the world.

If the people of Glastenbury were looking south and hoping to someday rival the large fern operations in other parts of the state, they ended up sorely disappointed. Ferns grow best in damp woods, shaded by all of the trees towering up above them. And of course, Glastenbury had already exhausted its forests of these trees. Fern picking is also not as easy a task as might be expected. The plants cannot be farmed. They're not lined up

in easy even rows where they can be harvested at a furious pace. People must hunt out the ferns in dark places in the wild and pick them just so or they won't come back again. Because they were used by the flower industry, the harvested ferns had to be perfect—no bruises or missing leaves. They needed to be picked, bundled, tied with twine and then carefully packed for shipment to a warehouse, all at the lowest temperatures possible so that the plants would keep.

In 1892, a senseless murder would be another blow to Glastenbury's morale. John Crowley, an itinerant lumberjack who was working for a short time in Glastenbury's last-remaining sawmill, was bludgeoned to death with a sled stake by Henry McDowell, a fellow millworker. Witnesses said the murder was unprovoked, but others had seen the two men arguing in the town bar the night before. Crowley, they said, feeling superhuman due to the effects of alcohol, had declared himself the boss of the lumber camp. McDowell, feeling equally invincible, had taken exception to Crowley's declaration. It was the kind of absurd conflict that can seem very important in the moment but is usually something to laugh about when one sobers up the next morning. Instead, this time, it led to cold-blooded murder. Seeing what he had done—and in full view of several coworkers—McDowell fled for Canada. Ten months later, he was in trouble with the police for another crime in South Norwalk, Connecticut, when they realized he was also wanted for the murder in Glastenbury, Vermont. McDowell was declared insane, ranting about voices in his head that compelled him to kill John Crowley, but he pulled himself together enough to escape before he could be sent to serve out his sentence at the Vermont State Asylum. Ironically, hidden in a railroad car full of charcoal, McDowell is thought to have finally made it to Canada, and he was not seen in New England ever again.

The fern industry was not what anyone had hoped it would be. The town was isolated from the communities around it. People began to talk of leaving for good. And that's when the news came that a Bennington, Vermont native named Herbert Martin wanted to repurpose the section of train tracks that led from Bennington to Glastenbury for a trolley that would ferry people on a winding trip to Camp Comfort, a rustic summer resort in the nearby town of Woodford. The Bennington and Woodford Railroad was born. On July 24, 1894, the first trolley car, purchased used from the New York village of Saratoga, was filled with hunters, fern pickers and a couple of wealthier tourists when it arrived at Camp Comfort.

At this point, the people of Glastenbury decided they needed to do something bold. A boardinghouse that had been used as a residence for

the lumberjacks and seasonal workers at the charcoal kilns was renamed the Glastenbury Inn and transformed into a summer resort, with a full casino attached. Across the street from the Glastenbury Inn, one of the defunct mills was converted to an entertainment hall, complete with a dancefloor and bowling alley. The trolley could transport tourists to and from Glastenbury, bringing an infusion of money into the economically depressed area.

The first season at Camp Comfort was said to be a success. Whether the company overstated its turnout or if something else was happening in the background, the resort was sold in a receiver's sale (most likely caused by an impending bankruptcy or foreclosure) as soon as 1896. As if the uncertainty around that wasn't enough, then a storm came in 1898. With the nearby mountains stripped of the old-growth forest that would cut winds and combat erosion, the storm flooded Glastenbury, destroying the boardinghouse turned resort and washing out several miles of train tracks. There was no way to come back from it. The railroad disbanded permanently, and residents began to move away. In 1903, there was a smallpox outbreak in the tiny remaining lumber camp in Glastenbury, which ended even that small operation for good.

Even with so few remaining residents, another notable death would follow in the early 1900s. On the first day of the hunting season, John Harbour, who lived in a neighboring town, went to Glastenbury to hunt. There were so few residents anymore that deer outnumbered the townsfolk. But the alarm was raised when John Harbour didn't come home that night. His body was found quickly. Harbour had been shot in the head and then dragged several yards before being propped up by a cedar tree in the Glastenbury forest. Police never decided if it was a murder or a hunting accident, and no shooter was ever identified.

In 1920, there were only seventeen residents of Glastonbury. By 1930, that number had dwindled to seven, and only three of them were year-round residents. At the point, all of the town's political positions were held by Judge Norman Mattison or one of his relatives. In 1937, the few residents who were left had not given up on Glastenbury, but the state of Vermont had given up on them. By an act of the Vermont General Assembly, the town was deemed an "unorganized town"—what most states call an unincorporated township—and a state-appointed trustee was placed in charge of whatever was left.

On November 12, 1945, an experienced guide named Middie Rivers was leading a group of hikers through the woods that surrounded the

former town of Glastenbury. On Long Trail Road, what was once a city street and then used as a hiking trail, the seventy-four-year-old Rivers turned a corner ahead of the group and was never seen again. Rivers had been hiking the area for most of his life, and it was expected that he had somehow gotten far enough ahead of his group that whatever trouble befell him no one could hear. But the hikers said his disappearance had seemed nearly instantaneous. One moment he was there, pointing out where farms once stood or how the land had looked during the charcoal boom, with all the trees chopped down, and then in the next instant, he was gone—gone and never to be seen again. The police were called quickly because of the age of Middie Rivers, and volunteers turned out in droves, despite the backcountry location. Only a single piece of possible evidence was ever turned up—a single rifle cartridge that would fit the weapon Rivers usually carried with him. It was spotted by one eagle-eyed volunteer at the bottom of a stream, leading people to think that Middie had seen something in the water that interested him, and he lost the shell as he leaned over to pick it up. But there was no way to concretely attribute the bullet to Middie Rivers, and it didn't explain what had happened to him.

A year later, nearly to the month, Paula Jean Weldon, a student at Bennington College, disappeared while hiking on Long Trail Road. Many friends knew of the girl's plans to go hiking in that spot, and, by chance, a newspaper reporter had given her directions when she got lost trying to find the trailhead. In an account that will sound familiar to anyone who knows the Middie Rivers story, an older couple saw Paula Jean on the trail ahead of them. The college sophomore turned a corner, slipping out of their view for what should have just been a second, and then she was never seen again.

Readers are undoubtably familiar with the notorious Bermuda Triangle, where hundreds, if not thousands, of disappearances have been attributed to unexplained or supernatural means. Some readers may even know that these loosely defined triangles of land where odd occurrences seem to happen at higher-than-average rates are theorized by some to exist in places all over the world. It is less well known that New England is supposed, by some, to have a couple of these triangles scattered around. The sad history of Glastenbury played a part, helped along by the stories of the historic murders that had not been forgotten by the locals, but the disappearances of Middie Rivers and Paula Jean Weldon were the real catalysts that created the legends that live on about the town to this day. Stories of bad luck, murder and unexplained disappearances, some rumored and some known to be very true, have all combined to give

Glastenbury a spooky reputation. The culmination of this came in 1992, when Vermont folklorist Joseph A. Citro began to call this little patch of land the Bennington Triangle, with Glastenbury Mountain smack-dab in the center of it. Believers in the triangle theory point to a number of disappearances that have all taken place—or have been rumored to have taken place—on Glastenbury Mountain. Most historians dispute a majority of the disappearances—Middie Rivers aside—as urban legends or as real mishaps that have their roots in perfectly explainable events. Believers also say that before the area was colonized, the Native tribes of the area feared Glastenbury Mountain and believed a man-eating stone could be found there. Glastenbury is also the setting for a handful of much more mundane and to be expected stories about UFOs and a hairy, eight-foot-tall, Bigfoot-like creature that's come to be known as the Bennington Monster.

Glastenbury and the nearby community of Somerset, which was unincorporated for the same lack of population growth, are now mostly owned by the United States Forestry Service. While, at the time, most residents didn't realize it, large swaths of Glastenbury had ended up being owned by Trenor W. Park. Park was born in nearby Woodford, Vermont, but would go on from his humble beginnings to become an important lawyer and politician. Park lived in many places during his life, going from Vermont, to New York City, to California and back again, but he always had a soft spot for his home state. Over the years, he would donate the land and buildings for the Vermont Soldier's Home, an art gallery for the University of Vermont and a public library for Bennington, among many statues and memorials that can be found all over the state. For whatever reason, one of the things he hung onto was the former town of Glastenbury. It was passed down the line until it came into the hands of Park's great-great-grandson Trenor Scott. Trenor Scott sold most of this land to the United States Forestry Service, keeping some amount of acreages for himself, an estimated fifty acres that are still Glastenbury in unincorporated form.

There is a single-lane dirt road about two miles long that leads into what remains of this part of Glastenbury that the Forestry Service doesn't own. But even so, in a town that is no longer a town, in a place that has every spooky story imaginable attached to it, you can still find a few hardy souls. In the 2008 census, there were eight residents of Glastenbury, living at least part of the year among the remains of the rest of the town.

Dogtown, Massachusetts

It's nearly impossible to write about abandoned villages in New England without saying something about Dogtown, Massachusetts. For those oftentimes unknowable reasons these things happen, Dogtown has fallen into the realm of popular culture. It has been immortalized in a song by Harry Chapin, has become the setting of many books and was the subject of a series of paintings by Marsden Hartley, created in the 1920s and 1930s.

The settlement was not always called Dogtown; in fact, speculation over the canine name is one of the charms of the village that has helped keep its story going, even after all of its residents have long been gone. Dogtown began its life with the names Town Parish and Common Settlement. Such a common name makes it easy to see why the more mysterious Dogtown moniker has stuck.

Located on Cape Ann in Massachusetts, roughly split between where Gloucester and Rockport exist today, Dogtown was settled in 1693. To the first settlers, it must have appeared like a nearly alien landscape. The land is liberally dotted with large glacial boulders. But it was just far enough inland that colonists felt protected from attack by sea and featured an abundance of clean freshwater—not always so easy to find so close to the salty ocean. The residents did well enough for themselves that the town hired a shepherd to watch, communally, over the flocks of sheep that were owned by all of the local farmers that grazed on the common. He was paid $300 annually—not an insignificant sum—which says something about the prosperity of the community.

In the late 1700s, the tides had turned for Dogtown—quite literally. With the American Revolution at an end, the coast was safer than it had ever been before. Fishing in Gloucester became a major driving force of the local economy. With the port in Gloucester shipping not just to Boston but overseas, even common sailors became wealthy men. Suddenly, it did not seem so smart to the residents of Dogtown to live inland with their sheep. As Gloucester became more of a hub, roads began to be built that bypassed Dogtown completely.

By 1828, Dogtown was all but a ghost town. Many houses stood decrepit and empty. Less savory people began to move into them. Some sources credit the Dogtown name to this period, either for the large dogs that were kept by the residents for protection or as an insult to the status of the people who had moved in. It was not just the poor who ended up in Dogtown. Anyone who did not fit the norm of the period might end up there—independent

women, same-sex couples, cross dressers and feminists, to use the modern terms. Many of the residents who remained—in truth, mostly older widowed women without the means to pick up and move elsewhere—were rumored to be witches.

Thomazine "Tammy" Younger is perhaps the most famous of the Dogtown witches. A self-styled queen of witches, she would stop wagons on the roads between the settlement and Gloucester, threatening to curse the oxen if she was not given food or money. In time, she became known for making butter and rum, "entertaining" men and reading fortunes in her Dogtown home. People said she had plenty of money and that she chose to live in Dogtown when she could have afforded to live in Gloucester, a notion that was as scandalous to some as her choice in career. But when the queen of the witches died in her Fox Hill home in Dogtown, the only riches she left behind were a snuffbox in the basement with just a few coins inside.

The last official resident of Dogtown, a freed man known as Black Neil Finson, left in 1830. It might be more accurate to say he was taken away rather than left. Found by some residents of nearby Gloucester, Finson's feet were nearly frozen off after living half-wild in a cellar hole of a former Dogtown home. They brought him to Gloucester for medical attention, and he spent the rest of his days there, living in the county poorhouse. Fifteen years later, the residents of Gloucester tore down what remained of the houses and left the cellar holes to mark where the town of Dogtown had once stood.

It was in the 1920s that Marsden Hartley, the famed painter, stopped in Gloucester. Hearing that there were the remains of an old ghost town nearby, Hartley thought it might be worth checking out. He did not expect to be so moved and inspired by the place he found. "A sense of eeriness pervades all the place," Hartley later wrote about Dogtown. "[It is] forsaken and majestically lovely, as if nature had at last formed one spot where she can live for herself alone."

So moved, Hartley made a series of paintings in Dogtown. Most feature the boulders the town is famous for; the works are somehow colorful and brooding all at the same time. They serve a marked contrast to the artwork one usually associates with Cape Ann—there's no ocean, no sail boats and nary a seagull to be seen. Part of what attracted Hartley seems to have been his contrarian nature. In other writings at this time, he crowed that in all the years of artists visiting Gloucester, he was the first and only to have painted Dogtown. In later years, Hartley would write a poem about the abandoned town, declaring unequivocally that "Dogtown is mine."

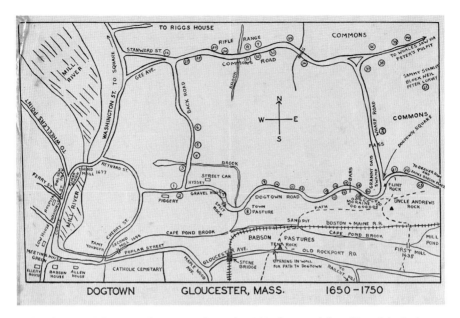

A historic map of Dogtown Commons, drawn in 1804. *Courtesy of the archives of the Annisquam Historical Society.*

But Dogtown, though empty, was not a place in stasis. Hartley returned to it in 1931 and 1934 and found it much different with each return. While Hartley and his paintings did a lot for Dogtown, it was the Babson family who really made Dogtown what it is today. J. Babson wrote a popular book on the history of Gloucester that brought the story of Dogtown to a wider audience for the first time. Between two of Hartley's visits, J. Babson's grandson Roger sold one thousand acres of the town so that it could be flooded to form a reservoir. During the Great Depression in the 1930s, this same grandson, in the interest of giving charity with dignity, hired unemployed stone cutters to decorate the many glacial boulders that were strewn around the Dogtown landscape between old cellar holes and pitted walking paths. The boulders, ranging in size from a Volkswagen Beetle to a middle-class family home, carry Babson's cheery little monikers into the present day. No-nonsense bold letters carved into the boulders say things like "STAY OUT OF DEBT," or "IF WORK STOPS VALUES DECAY." It may just be how the all capital letters read to people who are used to internet etiquette, but many seem more a threat than a kindly given piece of good advice.

Hartley didn't like the stone inscriptions either. After his last trip to Dogtown, he complained that the village had been altered from its natural state. He would never paint the chiseled boulders and stopped visiting entirely.

Today, Dogtown is part of Gloucester's conservation land. Beyond its historical interest, it's considered part of the watershed surrounding the reservoir, and development is prohibited. You can still follow the Dogtown roads past the cellar hole of Tammy Younger's house and see the carved boulders commissioned by Roger Babson.

Gay City, Connecticut

It's kind of sad to think that a town with such a merry name is abandoned. The ruins of this town are now called Gay City State Park, and it's a popular hiking spot near Hebron, Connecticut. But with a historic graveyard front and center, even from the first turn into the parking lot, Gay City announces itself as a place where people lived—for a time— and died. The cemetery has several impressive tombstones, but the most moving grave is among the smallest. Placed to mark the death of a seven-year-old girl, the inscription says, "Com pritty youth behold and see, the place where you must shortly be."

Depending on whose side you take, Gay City was formed either because of a feud or because of the near-cult-like devotion of a religious sect. In the eighteenth century there was a small group of Methodists living in Hartford, Connecticut. One view is that the Methodists were persecuted by their Hartford neighbors for their extreme devoutness and the relative youth of their religion. The perspective of the Hartford neighbors leaned more toward the view that the group was more like a cult than any religious group they cared to recognize. Alcohol was another touchy subject. The Methodist group in question liked their drink. Their neighbors were teetotalers.

By the 1790s, the group had decided to move on to a friendlier place. About twenty-five families were led by Elijah Andrus a little over fifteen miles farther along the Blackledge River. There, they created their own village, where they could live, worship and drink as they pleased, isolating themselves as much as possible from the outside world. Reverend Henry Sumner was in charge of the religious aspects of the group, but much of the town was made up of the Gay family. Church services were held twice a week, and when attendance flagged, free rum for every adult male was added to the ceremonies to encourage people to come. While church attendance may have improved, the reverence of the gatherings declined. As alcohol-fueled fights broke out during church, several of the families decided

to move on, Elijah Andrus among them. The families who remained named John Gay the leader of the community. John Gay, his brother Ichabod and Reverend Sumner formed an uneasy alliance, running the town from that time forward. It was a feud that would continue down the Gay and Sumner lines for generations.

The residents never called their town Gay City, however; to them, the community was Factory Hollow. The place they had chosen to call home may have given them the breathing room they needed for religious purposes, but it was poor farming land. They knew that in order to survive, they would have to create some other way of life. By 1804, just a few short years after forming the village, they had built a major sawmill, a wool mill and, of course, a distillery. Enormous stones, weighing over a ton each, were dragged into place by teams of oxen to create the foundations for the wool mill. In order to turn the enormous wheel that would power the mill, the residents had to dam off part of the Blackledge River and divert the water. The result was an odd canal that ran uphill and, according to legend, caused at least one worker to walk away from the job and refuse to come back or take part in any kind of "devil's work."

Whatever reservations people in the surrounding communities may have had about the religion or the drinking that was going on in Factory Hollow, they sure liked the mills. The William Strong and Company Wool Mill was a boon to local sheep farmers. The town prospered and grew—for a time. The War of 1812 caused major disruptions to the wool industry. When William Strong and Company started to fail, Reverend Henry Sumner swooped in and bought the entire operation, renaming it the Lafayette Manufacturing Company. But Sumner's luck was ultimately not all that better. In 1830, the wool mill, the most important driving force of Factory Hollow's economy, burned down. Several more families took that as an omen and left. Years later, Dr. Charles Sumner, the son of Reverend Sumner, built a paper mill over the site of his family's former wool mill. The other residents of Factory Hollow were glad to have the jobs, even if the paper industry never quite did for them what the cloth industry had. In modern times, a rumor persists that there was a button factory on the grounds because of how many buttons can still be found. The buttons actually came from the old clothing that was often used to create rag paper.

In the mid-1800s, two murders occurred in Factory Hollow—at least according to surviving legend. The body of a local jewelry peddler was discovered in a charcoal pit at the edge of Factory Hallow, apparently robbed and murdered. Then a blacksmith's apprentice was stabbed and beheaded by

his boss when the young man showed up late and drunk for work. There are no records that the murderer of the jewelry merchant was ever identified or that the blacksmith faced any consequences for his crime. For a community that had been built just fifty years earlier on religious ideals, it was a time of soul searching. Many of the young men, tired of working in the mills, left to fight in the Civil War. Most did not return, as they were either casualties of the war or had found greener pastures to settle in.

The town was shrinking, here and there, and life was getting tougher for those who stayed. Then, in 1885, the paper mill burned, just as the wool mill had before it. As in most other places where the main source of employment goes away, the residents of Factory Hollow began to leave. They drifted off a few families at a time, looking for work, until the only people left were a handful of people who were all descendants of the Gay family. In 1943, Emma Foster sold the land that was once Factory Hollow to the state of Connecticut to form a state park with the condition that they not purposely take down anything that remained of Factory Hollow and that the park be named after her Gay family ancestors. Gay City State Park was formed. And, as agreed, the state left what remained of Factory Hollow in place: cellar holes galore, the walls of the former paper mill and the cheery little historic cemetery that greets hikers as they pull into the lot.

4

BET THE FARM

There are many myths and misconceptions that have been built up around our ancestors in general and the early Americans in particular. We think of people from the past as somehow more capable than us—people who were able to live off the land, tame the wilderness, grow enough food for their families with fifteen kids and make by hand every single thing they could possibly need to exist.

The truth, of course, is that the people then were not all that different from people today. They had their skill sets. Some were great at taming the wilderness, and some were as helpless as you or I would be. The pilgrims—yes, those people with the funny hats of *Mayflower* fame—were businessmen and artisans who had spent years in metropolitan urban cities like Amsterdam and Leiden while those areas were in the middle of the Dutch Golden Age. William Bradstreet, one of the more famous among them today, had noble family ties and owned a series of mills. They themselves were so unsure of their own ability to survive without shops down the road to buy their necessities at that an additional fifty people, most of them farmers, were hired to accompany the pilgrims to the New World. The *Mayflower* arrived in Plymouth by mistake. Debate ensued, as the pilgrims were there not for religious freedom, as most school children have been taught, but because of contracted business obligations. There was fear that landing so far north of where their charter dictated would cost them, and there was also a fear that trying to find where they should have landed could result in starvation.

The pilgrims found a New World that was curiously already cleared of trees. The Natives had been burning and clearing the forests for generations to make room for farming and to make it easier to catch prey. The pilgrims took this as a sign from the divine, but they may have rethought that idea when the extreme hunger settled in their bellies. They had a hard existence, there's no doubt about that. But the struggle was not in clearing and taming a wilderness. It was a struggle born from their own inexperience with agriculture.

New England is not really the most fertile land. The New England states have short growing seasons, harsh winters and rocky soil. In England, people relied on wheat for bread as a staple crop. In New England, they learned to grow corn because wheat needed better soil. But there was, and still is, good fishing and a lot of lumber in the area. Early Americans learned to find new ways to survive. But at the end of the day, people will always need to eat. Farming is hard; it's as true today as it was for the pilgrims then. And some towns found themselves empty and abandoned because farming just couldn't be made to work for them.

Freeman Township, Maine

Before there was the city of Portland, Maine, there was the village of Falmouth, Massachusetts. That both Portland, Maine, and Falmouth, Massachusetts, were formed and grew in the same location is a matter of confusion for anyone not familiar with their early American history. Maine was, at one point, a province of Massachusetts. And while both modern-day Maine and Massachusetts have towns named Falmouth in them, neither are the one that first formed on the peninsula in Casco Bay, where Portland is today.

Falmouth was burned to the ground on October 18, 1775, by the British Royal Navy. It was meant to be the first of a series of attacks against any port city that was favorable to the Patriot resistance in the American Revolution. The attack on Falmouth began at 9:40 a.m. that October morning and lasted for nine hours. It has been reported that a total of three thousand shells, from cannonballs to musket balls and everything else in between, were fired on the village during the siege. That's one every eleven seconds for nine hours. Even so, Captain Mowat of the Royal Navy was dissatisfied with the damage done over that span of time, so he sent men ashore to burn

whatever was possibly left. The people of Falmouth were too busy getting to safety to worry about trying to save their homes. In the end, more than four hundred homes were destroyed, leaving nearly one thousand people homeless with winter fast approaching.

Massachusetts paid the 160 families most impacted £250 and sent rations of corn. Years later, the people of Falmouth were still reeling from the effects of this devastation. Massachusetts continued to send support and ultimately created two land grants for the survivors to form new towns away from the original site of the Falmouth settlement.

Freeman Ridge was one of these towns. It was granted in 1797, and the town incorporated in 1808. By 1840, over 800 residents called Freeman Ridge their home. The land was rocky but was said to be the most fertile of all of the land deeded to the Falmouth siege survivors. Together, the residents cleared thousands of acres of land, sold off the lumber and created rolling pastures for some of the largest sheep farms in Maine. Overall, the land grant was seen as a success. But less than one hundred years later, in 1930, Freeman Ridge was a town of only 219 residents. By 1937, the town packed it in completely, filing papers to became unincorporated. So, what happened?

For the most part, the Industrial Revolution seems to have been the death knell for Freeman Ridge. As the first textile factories began to be built across New England, the large sheep farms of Freeman Ridge did brisk business and enriched many residents. But wool did not end up predominating the industry of Maine's mills. First, the Saco Manufacturing Company created the country's single largest textile mill for processing cotton. Then the rich forests of the pine tree state, which cover an estimated 17.9 million acres, pushed logging and paper mills to the forefront of the economy. Finding themselves pinched by lower wool prices and more costs to export the fiber to processed, many former farmers decided to go to work in the mills themselves. Family by family, the population dwindled until it no longer seemed to make sense to be a town at all.

Today, all that remains of Freeman Ridge is a cemetery, with historic grave markers and a barn that is in the National Register of Historic Places. This structure, which has the unwieldly utilitarian name "Barn on Lot 8, Range G," was built in 1825, when the prosperity of the town was at its peak. It's an English-style barn with rough-hewn timber framing. Just before the fortunes of Freeman Ridge took a turn, an addition had been made to the original structure. There's some mystery as to the provenance of the barn; it's unclear who built it or who owned it for much of its existence.

"Barn on Lot 8, Range G" is the last surviving building of Freeman Ridge, Maine. It is in the National Register of Historic Places. *Courtesy of the Library of Congress.*

The barn itself seems to predate the house that currently stands next to it by about one hundred years. In property records, as far back as can found, it's only ever called Barn on Lot 8, Range G, so the name has stuck.

DUDLEYTOWN, CONNECTICUT

Dudleytown, Connecticut, was technically not ever really a town. In 1740, when the village of Cornwall was incorporated, so many members of the Dudley family took up residence in such proximity to each other that everyone started to call that little section of Cornwall Dudleytown. Previously, this part of Cornwall had been known as Owlsbury for the large number of the birds that roosted there before the Dudleys came to make their own kind of nests, which proves nothing if not that early Americans lacked a certain flair of imagination when it came to naming things. The Dudleys remained in Cornwall just long enough that the name won out over Owlsbury and stuck, even if it was never legally made a place of its own.

Dudleytown relied, like many early settlements, on farming. As the Dudleys cleared the land of forests to make room for farmers' fields, they were able to sell off the lumber and do pretty well for themselves. But once the timber was gone and they needed to rely solely on farming, they found that they had a much tougher time. The residents of Dudleytown had made two major tactical errors when deciding where to settle. Firstly, they were too far from clean water to drink or irrigate their crops. Secondly, Dudleytown was tucked into what is called Dark Entry Forest. The name might sound

like something out of a horror novel, but it was called this because of the darkness of the woods—they were shadowed by looming mountains. Water and sunlight, of course, are the basic things needed to be a successful farmer. After a rough twenty years or so, all of the residents had wandered off for (literally) greener pastures.

So, Dudleytown rose up just long enough to leave some cellar holes in its wake. In 1906, Dr. William Cogswell Clarke looked at the roughly cleared remains of the farms around Cornwall and bought about three hundred acres of them. He set about planting seedlings and hoped to reforest the area, returning it to a more natural state than what it had been left in. By 1924, Dr. Clarke had turned the project into something like a privately owned conservation company. Dark Entry Forest Inc. had forty-one shareholders and, within three years, had planted more than ten thousand new trees.

Dudleytown would probably have been long forgotten by anyone other than the local historical society had it not been for urban legends. Pre-internet, local rumors abounded about mysterious goings-on in Dudleytown. In the 1970s, things really started to pick up steam when Ed and Lorraine Warren filmed a Halloween special in what remained of the town. The Warrens were among the first celebrity paranormal investigators. Ed Warren, a self-taught demonologist, and his wife, Lorraine, a clairvoyant medium, formed the New England Society for Psychic Research in 1952. This was New England's first ghost hunting group, and it became a multimillion-dollar endeavor for the Warrens, who were able to catapult their investigations into lucrative book, movie and television deals. In time, dozens of blockbuster movies have come to be based off of the Warrens' paranormal investigations, including *The Amityville Horror* and its sequels and all of the movies in what is called the Conjuring Universe, including *Annabelle*, *The Conjuring* and all of their associated spin-offs and sequels.

The Halloween special filmed in Dudleytown was a sensation. The Warrens claimed the town was the victim of demonic possession. Long-whispered local rumors that a curse had plagued the town from its inception and led to its demise were spread far and wide. The story said that the Dudleys of Dudleytown were the descendants of the English nobleman Edmund Dudley, who was beheaded by Henry VIII for treason in 1509. The king, stories say, was so furious at the betrayal that he cursed the Dudley line for eternity.

With all of the Dudleys concentrated in a space called Dark Entry Forest 200 years later, it could only be expected that the curse would reach its full

power. While the curse is supposed to have led to the early death of anyone with the last name of Dudley, a number of other stories are also regularly shared about Dudleytown residents who had nothing to do with the town's namesake family. A popular Dudleytown resident named Gershin Hollister mysteriously fell to his death while helping raise a barn at the neighborhood home of William Tanner. Tanner swore for the rest of his life, and he lived to be 104 years old, that it was an accident, but many suspected foul play. The third wife of General Herman Swift, a longtime Dudleytown resident who served as an advisor to George Washington, was struck by lightning as she stood on her own front porch.

By the 1890s, only the Brophy family remained in Dudleytown. John Brophy was a no-nonsense man who said the tales of curses and ghosts were just that—stories made up to frighten children. He swore he could not be driven from his land. Shortly after, John Brophy was found staggering around outside the town limits, saying his wife had been murdered, his children had disappeared in the night and that his home had been devoured by a fire with a cause he could not explain. Even more chillingly, he swore that man-like creatures had pursued him from the remains of his home.

Modern-day genealogists have shown pretty conclusively that the Dudleys of Dudleytown were not related to Edmund Dudley. Many of the other stories told about this place are unverifiable or have proven to not be quite true. A suicide that is pointed to as one of many that plagued the town actually took place in New York state and not Dudleytown at all.

"For decades, there's been this perpetuation of misinformation," Michael Gannett, president of the Cornwall Historical Society, told the *New York Times* in 1989. "Go to Dudleytown, they tell you. It's this real ghostly place. But the truth is, Dudleytown's a big fraud."

If the people of Cornwall were fed up with the Dudleytown curse stories in 1989, you can imagine how they felt after the dawn of the internet age, when the legends spread faster than the truth. After busloads of tourists began to arrive to look for ghosts or got their cars got stuck in the mud trying to drive up the former carriage roads, the historical society decided to lay an end to such tales. It published a small book called *The Truth About Dudleytown* and hoped that would be the end of it.

And then *The Blair Witch Project* happened. The 1999 horror movie is set and was filmed in Maryland. It follows three teen documentary filmmakers hiking through the woods while investigating a local myth: the Blair Witch. Although there is no obvious connection to Dudleytown, the film seems to have kicked off a renewed interest in the secluded site.

Dark Entry Forest Inc. has had to close off its property to hikers, and to this day, the area is probably one of the most policed patches of woods in Connecticut. The Cornwall residents who live closest to the Dudleytown site are diligent about keeping an eye on who is walking in their neighborhoods. Even so, the local police say they issue several citations a month to trespassers on the property, nearly all of whom say they are interested in ghosts, not the site's history.

Sandwich Notch Hill, New Hampshire

With a current population that's less than half of what is was in the early 1800s, many would say that the town of Sandwich, which also includes the villages of Center Sandwich and North Sandwich, is certainly small enough, but it is no ghost town. It does, however, contain the remains of an abandoned town. This is probably not too surprising, considering that, at the time of its inception, the area was considered so inaccessible and so isolated that its charter made it—land wise, at least—one of the largest in the state.

Sandwich Notch Hill, located deeper in the realm of Dinsmore Mountain than the current city of Sandwich, can be found along the edges of Sandwich Notch Road. Historically, this pitted dirt road was a lifeline for farmers throughout northern New England. It can be considered one of the great interstates before interstates existed. The skilled craftspeople and farmers across Vermont and northern New Hampshire used Sandwich Notch Road to reach the wealthier communities of New Hampshire's seacoast and, most especially, the city of Portsmouth, which gave them access to markets across the East Coast for their goods.

Construction on the road began in 1803. Horses and oxen helped haul equipment and level the land as best as could be done. Sandwich Notch Hill residents were charged a two-cents-per-acre tax to help pay for the road's construction, a small investment considering what it meant to the town. It not only meant that farmers could bring their own goods to market, but they would also be able to charge other farmers for services like food and lodging, as they used the road themselves.

Sandwich Notch Hill was not particularly good land for farming, but being located directly on the main artery to markets more than made up for that. Sandwich Notch Hill grew quickly, and, at one point, it had three schools, a large meetinghouse, a popular tavern and at least two sawmills. One thing the community never had was the traditional little

white clapboard New England church. Instead, the village of Sandwich Notch Hill had Pulpit Rock.

This enormous glacial boulder towered above the tree line, looming over the town. It sat on land owned by Joseph Meader, a Quaker preacher. A Quaker preacher may seem like an oxymoron to some. Quakers, known to each other as friends, take Psalm 46:10, "Be still and know that I am God," quite literally. While the friends gather together for worship, most of the Quaker meetings are spent being still and silent, with the belief that, in this silence, it is easier to hear the small, quiet voice of God. Quakers—all Quakers, not just a single priest or religious leader—are welcome to speak at meetings if the spirit finds them. There is no sermon or traditional prayer.

But many Quaker meetings do begin with a "query," a question or idea for each person to ponder in their own way while waiting to hear the quiet voice of the spirit. Joseph Meader would climb to the top of Pulpit Rock, which lay several yards in front of his home, and stand there silently for some time before posing a query to the townsfolk spread out before him.

Meader loved the Notch and Sandwich Notch Hill most of all. In his queries, he usually implored the residents to travel back into the past in their mind's eye, to remember how the town was in its early years of being settled. Meader would tell them to think of the sounds of the hillside community in the early days—bleating sheep, howling wolves and the sounds of hammers reverberating through the forest as they built their small community. Those who gathered below would stand quietly in the middle of Sandwich Notch Hill and think their own thoughts. In time, someone might be moved to speak, or not, and after an hour or so, the gathering would end with people leaving in twos or threes.

Not every resident of Sandwich Notch Hill was a Quaker, though many were. Even those who weren't still made it part of their routine to stand underneath Pulpit Rock and follow Joseph Meader's query in their own way. Meader was a well-traveled man, thought to be highly educated and was deeply respected by his Sandwich Notch Hill neighbors.

But by 1860, the farming community that had once numbered several hundred residents had turned into a quiet enclave of just eight families. As other roads were built to bring goods to different markets and competition from larger farms increased, it just became easier for the farmers of Sandwich Notch Hill to go elsewhere. Some chose to keep farming, just in more habitable conditions; some moved to the cities to take up factory work. Most of those who left were part of the younger generation of Sandwich Notch Hill residents. As the average age of those who remained grew older

and older, they began to farm less and less land. As the farms shrunk, the forest began to encroach on the town, making it seem darker and more desolate, which led to more people deciding to leave.

By the end of the 1800s, even those last eight families were gone. Sandwich Notch Hill consisted of just one year-round resident, Moses Hall, and the remains of all of the homes of the residents that had come before him. As much as Moses Hall was the last man standing, today, his home is the only building that still exists on Sandwich Notch Road. It remains a private residence to this day.

After the death of Moses Hall, a railroad and timber operation bought the entirety of Sandwich Notch Hill and a good portion of the land around it. For many years, the area was logged aggressively. Once all of the good lumber was gone, the company moved on. In the 1930s and 1940s, several miles of the old train track that had been used to transport cut trees from Sandwich Notch Hill to the sawmills nearby were pulled up. That portion of land was sold to the state for the White Mountain National Forest.

But not all of the town of Sandwich Notch Hill had passed into state hands. A good portion remained in private ownership, passing hands from one to another with nothing really being developed there. Then, in the 1970s, concerns about a luxury condominium project in the area led to a "Save the Notch" campaign, which was wildly successful. The developer sold most of the land, including Sandwich Notch Hill and Sandwich Notch Road, to be included in the White Mountain National Forest.

The Sandwich Historical Society has done a lot of research into the important roll that Sandwich Notch Road played in the history of New England. The society offers a guide that points out more than fifty notable features along the road, most of them the remains of homes from the Sandwich Notch Hill community. Along the road, visitors can see a large bolder with "P. Wentworth. 6 mls 1836" chiseled into it; a precursor of the modern-day billboard, this sign advertised the Wentworth General Store that once existed in Sandwich Notch Hill. There's also a number of gravestones that can still be found. Many farms had their own family plots on their property, but the Gilman-Hall Cemetery can also still be found farther off the road. Pulpit Rock is still standing over the town in all its silent glory. All that remains of Joseph Meader's home behind Pulpit Rock is a well-preserved cellar hole. Sandwich Notch Road, at least nine miles of it, also still exists as a narrow one-lane dirt road, though it is closed in the winter months. Cars can traverse it, but drivers should be wary of the number of possible potholes they might bottom out on.

AND THEN THERE'S THIS ONE

The story of Ricker's Basin is a sad tale. Such a long series of unfortunate events went into the demise of this town that, while it could have been included in just about any of the previous sections in this book, it deserved a place of honor with a chapter all its own.

RICKER'S BASIN, VERMONT

The Ricker family has quite a convoluted story of their own. They originated from the Isle of Jersey, England, and immigrated to the Dover, New Hampshire area in 1672. Sometime later, a good portion of the clan made their way to Berwick, Maine. The Rickers must have either really liked their own family or were disliked as a whole by everyone else, because for whatever reason, they always seemed to move as a family unit. By 1816, three generations of the Ricker family were ensconced, mostly together, in New England. Then, in 1816, Joseph Ricker, the grandson of the original Joseph Ricker who immigrated from England, moved on his own to Waterbury, Vermont.

There are no records that survive to let us know if Joseph Ricker was trying to leave his family or if he was merely acting as the first scout for the rest of them. He bought an old farmstead at the base of a mountain

between Waterbury and Bolton, Vermont, and went to work repairing it. But by 1839, the whole part and parcel of the Ricker family had settled down around him. The family was so prolific and so concentrated that the mountain came to be known as Ricker Mountain.

The family formed a town all their own, usually called Ricker's Basin, though the name Ricker's Mill pops up from time to time in the historical record. All in all, as time went on, there would be something like fifty families in the settlement. While a great many of them still had the last name of Ricker, other families did work their way in over the years and grew the community with them. Between them all, they cleared nearly four thousand acres of woodland on the slopes of Ricker's Mountain. The Rickers began as farmers, but the location of Ricker's Basin was a poor choice for crop raising. Aside from the stony soil, the steep slope made the area prone to washouts. While everyone did have the benefit of a very large extended family nearby to help eek out a living from the poor soil, they quickly found that, as a farming community, they just could not make a real go of it. Even when the railroad was developed to pass near Ricker's Basin, most families were never able to produce more than what they could use, so there was nothing extra to send to be sold.

Having failed as a farming community, the Ricker families all pitched in together and built a sawmill. There were several streams cutting through their valley and plenty of trees on the mountains, and it seemed like this would be a more profitable proposition for everyone involved. But as you can probably guess, problems arose. Much of the lumber had already been cleared when forming the town and creating fields for the farms that never took off. And while there were streams coming down the mountain, most of them were nearly seasonal in nature. They were not made for serious lumber transportation or powering a sawmill. Three small sawmills were built in Ricker's Basin, but they never really created the boon that residents had hoped for when they were built.

By this point, many of the Rickers were more than a little aware that life in Ricker's Basin was pretty rough. And family togetherness only counts for so much. Many of the younger members grew up and grew away, striking out to make their fortunes in places with a little more opportunity. As the older generations passed on, the population plummeted. The one schoolhouse in town closed due to a lack of children to teach. It reopened in 1908 and closed its doors again in 1921.

In a sad twist of fate, the very streams that were not quite grand enough to make the sawmills successful began to flood. On November 3 and 4, 1927,

it was particularly bad. The ground has frozen solidly early that season. When a hard torrential rain came, it slid right down the mountainside and swelled every stream and river to untold proportions. Even those who lived up on the mountain had to climb onto their roofs to survive the flood. The storm was of such epic proportions that it impacted a good portion of the entire state of Vermont. But Ricker's Basin was particularly hard hit, with the entire town cut off from the rest of the state for a few days. Around fifty people died, taking the heart out of the small community.

The waters did finally recede. But as the water left, so, too, did several otherwise hardy souls. The Ricker family had dealt with poor soil, failing sawmills and a flood. What else could happen to them?

The answer is: more floods. As bad as the storm of November 1927 was, an even larger flood came through in 1934. Aside from stranding residents, it also washed out most of the roads that went in and out of town. With so few remaining residents, no economic way for them to support themselves and the massive amounts of damage that needed to be repaired, the State of Vermont decided to close the roads up for good.

Part of this decision was based on the state's desire to create a reservoir by damming up the small river that ran through Ricker's Basin. If anyone thought that the state closing roads and then buying up the impacted land was a calculated maneuver, they did not say so. Most of those who remained were happy to be bought out. There were Rickers in town right to the bitter end.

It took five thousand men of the U.S. Army Corps of Engineers and the Civilian Conservation Corps to complete the project. By 1938, the Waterbury Dam was complete. When the waters of the reservoir reached their depths, only part of Ricker's Basin was submerged. The dam prevented future flooding, but it did no good for the people of Ricker's Basin because they were already gone.

Life moved on. A power plant would be added to the dam in the 1950s. In 1962, the area that was Ricker's Basin would become part of the Little River State Park. The park loves to celebrate its unusual history, and visitors can pick up a self-guided tour map of all the things that were left behind by the Ricker's Basin townsfolk.

One of things that cannot be visited today is the original farm that started it all. Joseph Ricker's first spread once grew to one hundred acres and contained the first home built in the town. It was farmed, one way or another, continuously for almost one hundred years. But the last owner of the property, Peter Tatro, got into a property dispute with a neighbor.

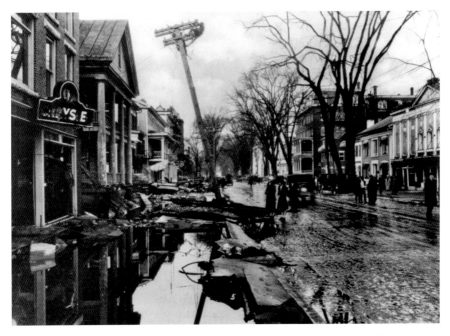

The aftermath of the 1927 flood led to the creation of the Waterbury Dam and Reservoir, which submerged what remained of Ricker's Basin. *Photograph courtesy of the Library of Congress.*

Convinced the parcel was about to be taken from him, he decided to burn the house down instead.

Considering the hardships that the township faced over the years, there is still a surprising amount left of it to see. Hiking trails wind through the former village, pitted with cellar holes, the remains of some farm equipment and other industries and even the Ricker Family Cemetery. The rapidly fading inscriptions on the tombstones are shaded by white cedar trees, which grow in a circle around the plot of land. It is said that the Ricker family planted the white cedars because they are called the tree of life. The last of the Ricker's Basin sawmills still leaves a footprint, although it was only in operation for six years. Where a team of thirty-five men once created wooden molds for shoes, there is now a concrete foundation; a large, rusted boiler; and a few sad woodworking implements. One landmark enjoyed by hikers is the stone foundation of Dan Dalley's farm. Dalley was a Civil War veteran who survived many historic battles and even escaped after being captured.

Local legend insists that, during drought years, the water level in the reservoir drops so low that you can see the rusted sunken remains of an old

metal bridge that once spanned the Liver River to connect Ricker's Basin to the surrounding area.

One house, through it all, remains standing. Almeran Goodell built the house using timber he hewed himself rather than relying on the town sawmills. Years after Goodell died, the house was bought by Howard Hough to be used as a hunting camp. The state bought the camp as part of the state park purchase. This home, too, would have undoubtably been given over to nature long ago, but a local Boy Scout troop has helped maintain it. From the outside, it looks much like it did when it was built over 140 years ago; inside, vandals have left their mark on the timeworn walls. Now, it is a haunting—and possibly haunted—reminder of the town that survived so much before being abandoned for good.

And that is why this one town, whose farms failed, whose mills could not prosper, that was felled by bad weather and was submerged underwater, earned a section all its own.

PART II

FOUND

Abandon [uh-ban-duhn]
Noun:

A thorough yielding to natural impulses.
especially: ENTHUSIASM, EXUBERANCE

—From the *Merriam-Webster Dictionary*

INTRODUCTION

As interesting as the history surrounding New England's old towns and villages is, there's something more than a little sad about considering all the places that have come and gone, oftentimes for the most depressing of reasons.

One of the best things about New England is the history of this place. Homes from hundreds of years ago still stand, and plaques commemorate the events and people that helped form a young country. Many educational and important historical sites, like Plymouth Plantation in Massachusetts or Slater Mills in Rhode Island, still exist and can offer a peek into the past as it was for the people who came before us. Other abandoned places have been put to new purposes that have no real tie at all to their past. Suburban Park in Unionville, Connecticut, is one such place. It's a great place to hike, but until a local Eagle Scout decided to put up guide signs explaining the site's history, many had no idea there had ever been a turn-of-the-century amusement park on the land.

Some places, otherwise lost and abandoned, have been reborn in such new and interesting ways, it's worth celebrating them a little. These may not be ghost towns, precisely, but they are some of the places where the past has not just been preserved but has been renewed in ways that make them as important for what they are now as for what they once were. They aren't museum pieces, but they are places that are full of new life and new ideas.

BENSON'S WILD ANIMAL FARM

HUDSON, NEW HAMPSHIRE

John T. Benson was born in Yorkshire, England, in 1879. It's doubtful that his parents could have ever imagined the unusual life young John would one day grow up to lead. As a child, he traveled around Europe with the Bostock and Wombwell Circus, where he discovered he had an affinity for animals and their training. At the age of eleven, he traveled with the circus on a tour of the United States, where his specialty act is said to have been wrestling a lion. Benson turned that unique talent into a much bigger job; within a few years, he would become the United States manager for the Hagenbeck Company, a German operation that was, for many years, the largest wild animal dealer in the world. Through his work at Hagenbeck, Benson would supply P.T Barnum with animals for his shows. It was because of his work with Hagenbeck that Benson also became a proponent of what we would recognize as a modern zoo—namely, fewer bars, larger spaces and more natural habitats.

Eventually, John T. Benson left Hagenbeck's employ and started picking up more zoo experience. He worked for two zoos in Massachusetts: Lexington Park and Norumba Park. One of the highlights of his career occurred in 1911, when he helped establish Boston's Franklin Park Zoo. As part of his work with zoos, Benson utilized a large warehouse on a wharf in Hoboken, New Jersey, as a waystation for animals as they were brought in on ships from around the world. But the people who lived in Hoboken were not enamored of the smells and sounds that came from the

Elephants supplied by Hagenbeck performing at the 1904 World's Fair. *Courtesy of the Library of Congress.*

warehouse, filled with animals that were being quarantined. Eventually, the complaints reached a loud enough din that the city told him he would have to relocate the operation.

So, Benson bought the 150-acre Interstate Fruit Farm in Hudson, New Hampshire. But he was not cut out to be a farmer, and his work with animals was not over. Benson struck out on his own, importing animals, rehabilitating them and selling them off to zoos and circuses around the country. Hudson had some advantages that made it an ideal spot for quarantine and shipping every kind of animal imaginable, from big cats to elephants and everything in between. The town was only an hour north of the hub of Boston. It also featured its own large train depot, with the Boston and Maine Railroad operating a station behind the grange hall. Soon, parades of wild beasts coming off the trains and walking to Benson's land became a common sight for the residents of Hudson.

The parades kicked up enough interest that Benson got tired of answering requests to come see the animals or running people off who had hopped the fences. Benson started to charge a small fee to visitors who wanted to walk the property and see what creatures were there. He actually thought charging admission would stop people from coming and would free up his schedule to focus on the business of importing and exporting animals. Little did he know that people were willing to cough up a nominal fee to see the creatures. Soon, Benson realized that the funds generated by admission fees were nothing to be taken lightly. Billing his setup as "The Strangest Farm on Earth," Benson created a sensation. He kept the ideals of Carl Hagenbeck in mind as his animal operation began opening to the public. He landscaped walkways for visitors to enjoy while he also carved out large swatches of land for the animal habitats. Barns were built so that warm-weather animals could escape from the cold.

By 1934, the animal farm was as much a part of the business as buying and selling the animals themselves. Benson's Wild Animal Farm had a parking lot that could accommodate more than five thousand cars at a time, and on the weekends, it still wasn't enough space to keep up with the visitor count. On Sundays throughout the 1930s, the Boston and Maine

Railroad ran special "Jungle Train" roundtrips between Boston's North Station and its depot in Hudson, New Hampshire, so that city dwellers could easily go see the famous animal farm. The $1.25 roundtrip train ticket included park admission.

Benson had learned well from his experience in Hoboken. He knew the success of his business required staying on the good side of his Hudson neighbors. To that end, he declared that Hudson residents could enjoy free admission. Benson also employed many town teens at his attraction. By a quirk of New Hampshire law, he could hire teens as young as fourteen for "farm work," and his farm was often the only place in the area where kids that young could find gainful employment. In addition to fair wages, at the end of each summer season John Benson would hand each teenager who had worked for him a gift certificate for $18.75 at a Nashua clothing store. He believed the kids needed to start the school year off with a new set of clothes.

John T. Benson made a worldwide name for himself as both an animal trainer and trader. He supplied Hollywood with the trained animals they needed for movies. Throughout the 1930s, Benson reigned supreme as the second-largest exporter of goldfish in the world. The New York State Fish and Game Commission hired Benson to keep the Adirondack Mountains well stocked with bears and moose for hunters. Even President Theodore Roosevelt held Benson's prowess as an animal whisperer in esteem. Benson traveled with Roosevelt to the Black Hills of South Dakota and even to Africa on hunting trips. Benson's beloved Great Danes, Freda and David, were gifts from the president to the Hudson, New Hampshire zoo owner.

Each year, the farm grew a little larger—a new attraction was added here, concession stands there. Eventually, it would grow to cover over two hundred acres. Visitors could be pulled in carts by goats or ride elephants—for a small additional fee, of course. At one point, Benson even built a life-sized ark on the grounds, and at 2:00 p.m. sharp, visitors could watch a reenactment of Noah's story from the Bible, complete with animals being paraded, two by two, around the landlocked boat.

In those early days, it was a particular specialty at Benson's to see animals dressed as people. Chimpanzees would be put in proper dress for a tea party, carefully dressed pigs pulled wagons that declared they were "bringing home the bacon" and he even somehow managed to pull a pair of little pants onto the roosters that pecked around the petting zoo. A pair of lions were "married" weekly, complete with a jacket and top hat for the "groom" and a flowered dress and and matching hat for the "bride." But not all the

attractions at Benson's Wild Animal Farm involved living breathing critters. At one point, two supposed Egyptian mummies graced the grounds; they were said to have been brought back by Benson after one of his safaris. Visitors could even see the skeleton of the beloved Ringling Brothers elephant Old John.

When rationing began due to World War II in 1943, Benson made the difficult decision to close the park. He would not see it reopen. John T. Benson died the very next year. But Benson's Wild Animal Farm lived on. Four wealthy investors from Boston bought the property and all its inhabitants. The animal trade that began the enterprise was ended without Benson there, but the park itself lived on.

The new owners might not have had experience in the animal trade, but they did know a thing or two about business. Between the four of them, they owned the Boston Garden, a chain of gas stations and, later, the Celtics basketball team. But in time, their interest in the strangest farm on earth lagged. Eventually, just one of the four was left to run the entire thing, and the grounds and attractions started to slowly decline.

Benson's Wild Animal Farm got new life, thanks to Arthur Provencher. Provencher owned a successful industrial park in nearby Merrimack, New Hampshire, but at heart, he was a natural-born showman. In 1979, he bought the park and invested heavily in not only returning it to its former glory but expanding on that glory. Provencher added, among other things, a large gift shop, an arcade and a model railroad exhibit. Provencher reveled in riding the largest elephant in the zoo's collection during the daily parade. He renamed the park's five-hundred-pound silverback gorilla and decided it was the prime time to capitalize on New Hampshire's first-in-the-nation primary status. Colossus G. Benson, it seemed, was destined to run for president. But the presidential hopeful faced one major hurdle: he was just too huge to go to Concord himself to file the necessary paperwork. Luckily, a more easily transported chimpanzee was named the official campaign manager and could go to Concord for the photograph opportunity. For a while, attendance did increase with the new attractions and other shenanigans but, unfortunately, so did the expenses. The park closed for good on October 12, 1987.

Pieces of Benson's Wild Animal Park were quickly sold off and scattered across the country. The Great Escape in Upstate New York, now part of the Six Flags family, bought several of the rides. Benson's roller coaster can still be found in New Hampshire, a few hours north in the Santa's Village Park. A Salem car dealership carted away a fiberglass bull.

Top: The former animal barn under renovation during the revitalization of Benson Park. *Courtesy of the Library of Congress.*

Bottom: Benson Park visitors can now walk freely in and out of the cages that once housed the zoo's popular gorillas. *Photograph by Renee Mallett.*

The park was quickly reclaimed by nature. It became a hotspot for local teenagers to try out their graffiti skills. The final blow came when the historic barn on the former park property burned to the ground in a suspected case of arson. The state's department of transportation purchased the land for $4 million, saying it would be used to mitigate the impact on wetlands when a new highway was built. But twenty-two years passed, and the highway never appeared.

Benson's Wild Animal Farm would have ended up as just another chapter in a book like this had it not been for the residents of Hudson. Beginning in the 1990s, the town started putting money aside to eventually purchase the Benson property. In 2009, the sale was complete, with the town of Hudson buying the property for $188,000. More than two hundred volunteers helped clear the land, including a troop of Cub Scouts who cleaned graffiti off the remaining structures. Swan Lake was restored to its more natural state, with paved walking paths wandering through the landscaped grounds.

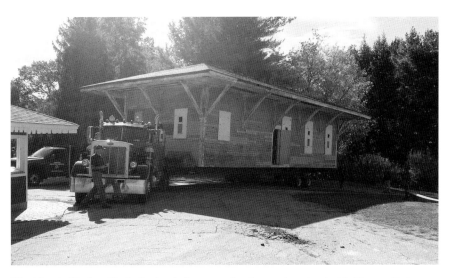

The historic Hudson Train Station being moved to its new location inside Benson Park. *Courtesy of the Library of Congress.*

There are several spots across New England where former zoos or amusement parks have been turned into hiking trails (the Suburban Park Trail in Connecticut is one of these). What makes this one different is that Benson's Park has not abandoned its unique past. Cages where animals once captivated audiences now stand open for kids to explore. A large A-frame building now serves as a picnic shelter. Even the old train depot where Boston and Maine railroad riders once debarked for a day at the zoo has been restored and moved to the grounds of the former Benson's Wild Animal Farm.

MILL NO. 5

LOWELL, MASSACHUSETTS

There's a lot of misconceptions about the city of Lowell, Massachusetts. Ask the average New Englander what they think of Lowell, and you will probably hear a lot about the city's age, its urban atmosphere and all of the negatives that people who don't live in cities think about them. But both the history and the current state of the city are full of surprises.

Lowell was incorporated in 1826, a relatively recent time, especially when compared to the age of some of the other towns mentioned in this book. It was built to be a mill town very purposefully, and if nothing else, Lowell has always succeeded in being just that. It was the brainchild of Nathan Appleton, who was born in New Hampshire in 1779. If Appleton's early life could be described in just one word, that word would be *restlessness*. Appleton did well at school but dropped out of his second year at Dartmouth to work for his brother in Boston. The next year found him in England. It was a trip that would change the course of his life. While in the industrial cities of England, Appleton was shocked at the squalor and extreme poverty of the millworkers. He recognized a great opportunity in the mills and what they could accomplish, but he felt that the English model came at too high a social and human price. Appleton traveled between Boston and England several times in the coming years. Eventually, he made his way to Scotland, where he had heard the millworkers faced a much different sort of life than they did in England. In Scotland, Appleton crossed paths with Francis Cabot Lowell, a cousin several times removed, who was as interested in investing in mills as he was. Francis Cabot Lowell introduced Appleton to the textile manufacturer

Robert Owen. Owen shared the two men's ideals about social reform and was already experimenting himself with cooperative communities.

Armed with these lofty ideals and a not insignificant amount of money, Lowell and Appleton returned to the United States to see if they were as good of mill owners in practice as they were in theory. In 1813, they built the first power loom in the United States in Waltham, Massachusetts. Appleton, in order to ensure a decent quality of life for his millworkers, realized he would need to be involved in nearly every aspect of their lives outside of work. He bought boardinghouses, stores, schools and banks. It was not quite what he was hoping for when he was daydreaming in Scotland, but it was the first step.

Appleton used the money he made from this venture to form another company and build another mill. Appleton added more and more factories, eventually owning interest in twenty-four textile manufacturers. The settlement that grew up around these ventures would eventually become the city of Lowell. By 1850, Lowell had become a major industrial hub, and by 1860, it is said the city contained more cotton spindles than could be found in all eleven of the southern states combined.

The Appleton Manufacturing Company would take up a good portion of the city for most of the beginning of Lowell's history. But starting in the 1920s, many companies began to relocate farther south. When Appleton Manufacturing left in 1927, its huge complex of buildings was leased to several other smaller companies, including the Suffolk Knitting Company. As a whole, these companies and the city were hard hit by the Great Depression. By the end of the Great Depression, only three of the city's major textile mills were still in operation. When World War II came about, there was short-lived resurgence in mill work—making parachutes for the military, mostly.

As in other places, the mills were a great boon for the city until they were not. As industry and manufacturing moved overseas, the city of Lowell found itself more and more a city of very large brick buildings with no big manufacturing companies left to fill them. The city turned toward cultural events rather than manufacturing to bring life back to Lowell. In 1992, Lowell started hosting the largest annual free folk festival in the country. Many other festivals celebrate the art and culture of Lowell's Cambodian immigrant community, the second largest in the United States.

But always in the background, there were the mills. Big, hulking buildings of red brick, many sitting empty or with just a few small industrial tenants, where, before, one company took up multiple buildings. Developers bought

Although it looks like one building, this is actually three mills that grew together over the years. On the far-left side is Nathan Appleton's original 1813 mill; other parts were mills or additions built in 1816, 1843 and 1852. *Photograph courtesy of the Library of Congress.*

Like many of Lowell's buildings, the Massachusetts Mills began as textile factories but had to be put to new purposes after the Great Depression. *Photograph courtesy of the Library of Congress.*

some, looking to turn them into condominiums or apartments, but the city wasn't looking to rezone the buildings to make those uses possible. Over time, some were demolished to make way for newer buildings, and some were seized by the city so it could work them into its own plans for the future.

Mill No. 5 was originally one of the Appleton Manufacturing Company buildings. In a bit of irony, back in the day, it was known as the "New Mill," since it was constructed in 1873, years after the original factories, but it is the oldest factory in the Appleton complex to still survive today.

Jim Lichoulas Sr. bought the Appleton property, along with several others, in 1975. Like other developers, at the time, he thought the mill would make a great building for apartments. But with the will of the city planners working against him, the project would remain in limbo. Years passed, and one by one, the floors in Mill No. 5 filled up with different ventures: a charter school, a designer of custom transformers and, yes, eventually some apartments. But the fourth and fifth floors of the building remained empty.

Eventually, those two floors were developed but not in a way that anyone expected and not by Jim Lichoulas Sr. His son, Jim Lichoulas III, took the reins on a new kind of project that combined the best of the old and the new. Mill No. 5 has become a multiuse space that acts as a center for the city's modern creative professionals, while also giving a nod to the historic Lowell community centers that no longer exist. A movie theater, milkshake bar and coffee shop rub shoulders with an art gallery, comic shop and other artisan-based businesses. Part of the charm is the undeniably authentic aesthetic.

Long before Mill No. 5 had been envisioned as a community destination, Jim Lichoulas III had been salvaging antique storefronts and other architectural fixtures. As other developers tore things down, Lichoulas came in and collected them. He saved the doors from the house of Dr. Suess and storefronts from as close by as Boston's Back Bay and as far away as London. While the items gathered from farther away may seem as if they

should be more exotic, for Jim Lichoulas, the focus was always on Lowell itself. "If I can save it for Lowell, that's great," Lichoulas told *MassLive* in 2019. "If I can save it from someplace else, that's good, too, but that's second choice."

Jim took inspiration from such diverse places as the artist

Above, left: The Luna Theater shows quirky, art house and nostalgic films. *Photograph by Renee Mallett.*

Above, right: Mill No. 5 features a full streetscape made from salvaged storefronts inside an old textile mill. *Photograph by Renee Mallett.*

Left: Embracing vintage features, like this twisting staircase, is part of what adds to the authenticity of Mill No. 5 *Photograph by Renee Mallett.*

communities that were starting to pop up around Lowell to New York City's Chelsea Market. Even Downtown Disney played a role, though the most important factor in the creation of Mill No. 5 was that it be as authentic and organically created as possible. All of the antique bits and pieces that Lichoulas had saved from the wrecking ball came into play.

To enter Mill No. 5, visitors walk under the building to a hot-pink elevator. When the doors open on the fourth floor, you can always tell when someone is visiting for the first time. Even if they've been told what to expect, it's hard to wrap your mind around an entire streetscape, pieced together from

salvaged storefronts from across the city, built inside of the fourth floor of an industrial mill that was built in 1873. Jim Lichoulas says that same disbelief followed the project from its conception and that he had to build it before people would believe it.

Today, Mill No. 5 is not just a place for small businesses to bloom or customers to come and shop; it serves as a gathering place where people share ideas and experiences.

MONSON CENTER,

NEW HAMPSHIRE

Plenty of the towns in this book have been replaced by state parks. Monson Center is unique in that the park was formed because of the town and not formed in place of the town. It is considered one of the most important archaeological sites in New England, but it was very nearly lost before a group of concerned citizens saved it for all of us.

Six colonists from Massachusetts and Canada bought the land that we now know as Monson Center in the early 1730s. Within a few years, they had moved their families there, built homes and cleared the land. Monson Center was the first known inland village to be built by European settlers in New England. It began as a village in Massachusetts. When the state borders became better defined eleven years after the town's inception, Monson Center suddenly found it belonged to New Hampshire.

Although it's believed that, at one point, many people called Monson Center home, the 1767 census says 293 residents lived there; the town itself did not last all that long. In 1770, the residents asked that the town charter be repealed. The town was deserted, though historians still continue to debate why. In many ways, it was an unusual village. The residents never built a school, church or meeting house. Records survive that say the residents put these kinds of community services up to vote at many town meetings, but they were voted down year after year. The largest community structure was probably the pound that was created to corral escaped livestock.

This inability to agree on relatively simple things like a meeting house or school is thought to be one of the reasons the townsfolk asked for the town

The early colonial settlement of Monson Center is now a park in its own right. *Photograph by Renee Mallett.*

charter to be repealed. Some records indicate that some of the Monson residents lived in extreme poverty and that social stratification also led to the town's demise. Tax records show that a large percentage of the land was owned by nonresidents who were not subject to the same sort of taxation as those who lived in town. If the charter was repealed for any of these reasons or for all of them, the petition to end the town was granted, and the land was split up among the towns that surrounded it. In the same way, the residents of Monson seem to have split themselves between the surrounding communities. Many of the names that can be seen in the records from Monson pop up again just a few years later in Hollis, Amherst and Milford.

Perhaps because of the relatively short period Monson Center existed, it was all but forgotten in modern times. For more than 220 years, the town waited, unknown to many, while the forest closed in. Also closing in was modern development. In 1998, a subdivision, a twenty-eight-home neighborhood, was proposed on the same land where Monson Center had been built. Led by the descendant of one of the original settlers, a group called the Friends of Monson saved the site from development.

Today, 280 acres of the town are open to the public. It is not so much a place to hike or a park as it is a way to step back into the past. The fields have

Left: Rock walls are common across New England; they are featured extensively throughout Monson, delineating where one homestead began and another ended. *Photograph by Renee Mallett.*

Below: Originally the home and clock shop of Joshua Gould, this house has been carefully restored and now serves as a small museum for Monson Center. *Photograph by Renee Mallett.*

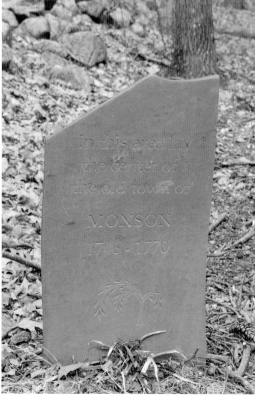

Left: It is, perhaps, fitting that the monument marking the center of this ghost town looks like a gravestone. *Photograph by Renee Mallett.*

been cleared, the original stone walls still separating one farm from the next, and the dirt road that once marked the main street of the village is plain to see. Signs next to each foundation give a fascinating bit of history about the families who once lived in the homes. Most surprisingly, a home still exists on site. The Jay Gould house was fully restored by caretaker Russ Dickerman. The two-room home was once a farm and clock workshop. Today, it acts as a welcome center and museum for Monson Center.

But Monson Center probably has no need for an official welcome center. The park itself is welcoming; it invites visitors to walk the grounds and use the land. It is not a place where the history is roped off to be looked at but not touched. In many ways, visitors will probably never feel closer to the early Americans who settled New England than they will when visiting Monson Center. As far as ghost towns go, it is a place where the past and the people who once lived there can be heard loudly and clearly.

BIBLIOGRAPHY

Allen, Mary Emma. "Step Back in Time as You Travel Sandwich Notch in New Hampshire's White Mountains." www.theheartofnewengland.com.

Anderson, Cynthia. "The Mystery of Dogtown: New England's Most Famous Abandoned Settlement." *Yankee Magazine*, October 24, 2008.

Atwood, Caroline V. "Livermore: Abandonment, Exploration, and Nostalgia." Digital Atlas of New England Landscapes. www.people. matinic.us.

Bell, Michael Mayerfeld. "The Ghosts of Place." *Theory and Society* 26, no. 6 (December 1997): 813–36.

Bidgood, Jess. "In Maine, Local Control Is a Luxury Fewer Towns Can Afford." *New York Times*, January 16, 2016.

Blanchard, Fessenden S. *Ghost Towns of New England: Their Ups and Downs.* New York: Dodd, Mead and Co., 1960.

Boston Globe. "Maine Village About to Die Has Farewell Celebration." July 7, 1949.

Bourgault, Bethany. "Lost Towns of the Quabbin Reservoir." *New England Today*, November 2, 2020.

Brooks, Rebecca Beatrice. "The Witches of Dogtown." June 21, 2012. www. historyofmassachusetts.org.

Brune, Adrian. "A Village of Curses?" *Hartford Courant*, October 25, 2006.

Cann, Donald, and Gayle Kadlik. *Images of America: Star Island.* Charleston, SC: Arcadia Publishing, 2015.

Cann, Donald, John Galluzzo and Gayle Kadlik. *Images of America: Isles of Shoals.* Charleston, SC: Arcadia Publishing, 2007.

Carnahan, Paul, and Nancy Remsen. Ricker Family of Waterbury Papers, 1760–1908. MS 146. Vermont Historical Society. Barre, Vermont.

Cook, Greg. "The Mysterious Boulders in Gloucester's Dogtown Woods." November 10, 2016. WBUR.

D'Agostino, Thomas. *Abandoned Villages and Ghost Towns of New England.* Atglen, PA: Schiffer Books, 2008.

Deetz, James. *In Small Things Forgotten: An Archaeology of Early American Life.* New York: Anchor Books, 1996.

DiLella, Angela. "Dudleytown: The Most Haunted Town in Connecticut?" July 20, 2019. www.gravereviews.com.

Donegan, Kathleen. *Seasons of Misery: Catastrophe and Colonial Settlement in Early America.* Philadelphia: University of Pennsylvania Press, 2014.

Dooling, Michael C. *Clueless in New England: The Unsolved Disappearances of Paula Welden, Connie Smith and Katherine Hull.* Carrollton, IL: Carrollton Press, 2010.

Doyle, Rachel. "Converted Textile Mill Incorporates Pieces of Dr. Seuss' House." *Curbed,* March 13, 2015.

Emlen, Rob. "200 Years Ago Today: Remembering the Great Gale of 1815." *Providence Journal,* September 23, 2015.

Goldsack, Bob. *Images of America: Bensons Wild Animal Farm.* Charleston, SC: Arcadia Publishing, 2011.

Hamatui, Ndinomholo, et al. "Respiratory Health Effects of Occupational Exposure to Charcoal Dust in Namibia." *International Journal of Occupational and Environmental Health* 22, no. 3 (2016): 240–48.

Harkavy, Jerry. "Survivor's Flood of Memories: Progress Put Maine Village at the Bottom of a Lake 50 Years Ago." Associated Press, September 1999.

Harris, Gordon. "Dogtown, It's History and Legends." www.historicipswich.org.

Hawke, David. *Everyday Life in Early America.* New York: Perennial, 2003.

Heath, Douglas L., and Alison C. Simcox. *The Lost Mill Village of Middlesex Fells.* Charleston, SC: The History Press, 2017.

Herwick, Edgar B. "The Towns That Were Lost So Boston Could Have Clean Water." May 14, 2014. www.WGBH.org.

Lamb, Jane. "Flagstaff Found." *DownEast Magazine,* October 2009. www.downeast.com.

Lawson, Russel M. *The Isles of Shoals in the Age of Sail: A Brief History.* Charleston, SC: The History Press, 2007.

Mann, Charles. *In the Heart of Cape Ann or the Story of Dogtown*. Gloucester, MA: Procters Brothers Publisher, 1896.

Marteka, Peter. "Hiking Through the History of an Abandoned Unionville Amusement Park." *Hartford Courant*, April 26, 2019.

Morrow, James F. "Forever Livermore." *Yankee Magazine*, November 1969.

New Hampshire Chronicle, WMUR. "Fritz Wetherby: Pulpit Rock and Joseph Meader." September 14, 2017.

Ocker, J.W. "Livermore Is a Strange Name for a Ghost Town: Lost New Hampshire Village Echoes Through Time." *New Hampshire Magazine*, July 15, 2020.

Parker, Paul Edward. "What and Why R.I.: Hanton City, a Missing Ghost Town in Smithfield." *Providence Journal*, October 31, 2019.

Rhinelander, David. "Gay City Undone by Firewater, Fire." *Hartford Courant*, September 11, 1998.

Rierdon, Andi. "The View from Dudleytown: A Hamlet That Can't Get Rid of It's Ghosts." *New York Times*, October 29, 1989.

Rutledge, Lyman. "Ten Miles Out: Guide Book to the Isles of Shoals." Isles of Shoals Unitarian Association, 1964.

Taylor, Alan. *American Colonies*. London, UK: Penguin Books, 2001.

Thommen, Gustave. "Notes on the Fern Leaf Industry." *American Fern Journal* 12, no. 4 (1922): 122–25.

Turner, John G. *They Knew They Were Pilgrims: Plymouth Colony and the Contest for American Liberty*. New Haven, CT: Yale University Press, 2020.

Walsh, Ken. "Visit the Ruin's of Waterbury's Little River Settlement." *Stowe Today*, June 21, 2010.

Wang, Lucy. "Eclectic Mill No. 5 Is an Innovative Hipster Haven Housed Within a Converted Textile Mill in Lowell." *InHabit*, March 12, 2015.

Weekes, Julia Ann. "Settlers May Have Abandoned Monson Center in 1770, But It's a Pretty Ghost Town Today." *Union Leader*, July 30, 2020.

White, Murray. "Marsden Hartley's Dogtown: An Eerie Expanse Where 'Nature Can Live for Herself Alone.'" *Boston Globe*, April 23, 2020.

The following websites were instrumental in researching this book:

www.ConneticutMills.org
www.CowHampshireBlog.com
www.DeadRiverAreaHistory.com
www.LegendofDudleytown.com
www.MaineanEncyclopedia.com

www.MaineMemory.net
www.mtdhistoricalsociety.org
www.NewEnglandAviationHistory.com
www.NewEnglandHistoricalSociety.com
www.NewHampshireHistory.org
www.ObscureVermont.com
www.Vermonter.com
www.VermontHistory.org
www.VisitMaine.com

ABOUT THE AUTHOR

Photograph by Megan Moore.

Renee Mallett is the author of many books about the legends, history and lore of the New England states. Her creative fiction and poetry have been published in a number of literary journals. When not writing, she is the soap maker behind the company Amaranth & Rue and owns Pop Cultured, an independent bookstore located in Lowell, Massachusetts. She holds a bachelor of arts degree in creative writing and is working on a masters in history.

Renee Mallett lives in southern New Hampshire with her family. You can visit this author at her creative space in North Chelmsford's Nova Art Studio the third Thursday of every month or online anytime at www.ReneeMallett.com.

Visit us at
www.historypress.com
..